The Campus History Series

VIRGINIA TECH
NELSON HARRIS

The Campus History Series

VIRGINIA TECH

NELSON HARRIS

ARCADIA
PUBLISHING

Published by Arcadia Publishing
Charleston SC, Chicago IL, Portsmouth NH, San Francisco CA

Printed in the United States of America

Library of Congress Catalog Card Number: 2004102683

For all general information contact Arcadia Publishing at:
Telephone 843-853-2070
Fax 843-853-0044
E-mail sales@arcadiapublishing.com
For customer service and orders:
Toll-Free 1-888-313-2665

Visit us on the Internet at www.arcadiapublishing.com

To my son Andrew.

CONTENTS

ACKNOWLEDGMENTS

This is now my fourth title with Arcadia Publishing, and I am most grateful for their encouragement, patience, and partnership in the production of this book. I extend special appreciation to my editor for this title, Susan Beck. This book would not have been possible without the assistance and permission of the archive staff at University Libraries, Virginia Polytechnic Institute and State University. All images contained in this book come from the VT Image Base (http://imagebase.lib.vt.edu/), housed and operated by Digital Library and Archives (DLA), University Libraries and scanned by Digital Imaging, Learning Technologies, Virginia Polytechnic Institute and State University (VPI&SU). They are to be commended for their extensive archival photograph collection. Not only is it accessible but also well documented and preserved. For working with my orders and providing information necessary to acquire the images contained in this book I give special thanks to Jane Wills, Digital Library and Archives Assistant. Information for the captions came from either the Digital Library and Archives, or from the comprehensive history of Virginia Tech, *The First 100 Years—A History of Virginia Polytechnic and State University*, written by Duncan Lyle Kinnear (Blacksburg: VPI Educational Foundation, Inc., 1972).

As always, I am most grateful to my wife, Cathy, for her constant love and support for all my projects.

INTRODUCTION

Anyone who has lived in Southwestern Virginia has been impacted by the commonwealth's largest university, the Virginia Polytechnic Institute and State University, commonly known as Virginia Tech. Virginia Tech's academic, athletic, and economic influences extend well beyond the borders of her campus. With an enrollment in excess of 25,000 students, Virginia Tech has achieved its goal of becoming a research and learning institution of national repute.

Virginia Tech officially opened its doors as the Virginia Agricultural and Mechanical College in 1872, assuming the grounds of the former Preston and Olin Institute, a Methodist academy founded in 1851. VAMC was made possible by the allocation of monies appropriated by the Virginia legislature from its land-grant fund for the establishment of an agricultural and mechanical school for white male students. Charles C. Minor was installed as president of the college, and the school concluded its first academic session with an enrollment of 132 students. The first graduating class in 1875 awarded 12 students diplomas. For the remainder of the 19th century, the college survived a number of changes. In 1880, enrollment dropped to 50 students, and during that decade the school was served by four different presidents. By the late 1890s however, the college had stabilized, awarding its first graduate degree in 1892 and enrolling 300 by 1896. The college also began to forge an identity, adopting school colors, a seal, and motto. The publication of the first yearbook in 1895 and student newspaper in 1903 added to the sense of an academic community.

In addition to academic and capital improvements, the college's spirit was heightened by the inclusion of intercollegiate athletics. The first baseball game was in 1877 and football followed in 1891. An athletic association was formed that same year. Professors, serving as coaches, often penned their own invitations to neighboring schools for competitions.

As Virginia Tech entered the 20th century, changes were legion. Women were finally admitted to the institution in 1921—five to be exact, with seven part-time—much to the howls and protests of the male students. In 1924, participation by upper classmen in the cadet corps became optional. In 1942, Tech would award its first doctoral degree. Meanwhile, under the visionary leadership of its presidents and boards of visitors, Tech's campus underwent significant changes with the inclusion of new academic buildings, dormitories, and athletic facilities. Following World War II, enrollment topped 5,000, with much credit due to the Montgomery G.I. Bill. By 1949, Tech was granting over 1,000 degrees annually.

Virginia Tech, like many colleges and universities in the American South, advanced with the movement to integrate its student body by opening its doors to African-American students in 1953. The first African American to graduate from Tech was Charlie Yates, who received a degree in mechanical engineering in 1958. Tech became the first state university or land grant school in the former Confederacy to mark this achievement. It was not until 1966 that the first African-American women arrived on campus.

By the late 1960s and 1970s, Tech would continue to undergo numerous changes. In 1967–1968, Tech's enrollment surpassed the 10,000 mark, and in 1970 the school officially became named "Virginia Polytechnic Institute and State University." In 1973, the corps of cadets admitted women to its ranks, and by 1978 Tech's enrollment had doubled to 20,000 students.

Today, Virginia Tech hosts 25,000 students enrolled in 60 bachelor's degree programs and 110 graduate programs. The main campus has developed to encompass 2,600 acres containing over 100 buildings and an airport.

Virginia Tech is continually listed as one of the top research universities in the United States, with annual research expenditures of $170 million. The university's budget now exceeds $740 million annually. Tech is proud to have 165,000 alumni from every state and 100 countries

The Virginia Tech of today certainly exceeds anything Charles C. Minor and his three faculty members could have dreamed when they opened for learning in 1872. Their vision, even if at times limited to just survival, has been passed along, renewed, and transformed to meet the challenges that a century and a quarter have presented to produce the renowned university that is today's Virginia Tech. So, to those 132 farm boys who arrived in the township of Blacksburg in 1872 to get schooled in the agricultural and mechanical trades appropriate for their day, we can only say, "Look at us now!"

Through the use of archival photographs, this work seeks to chronicle the growth and development of Virginia Tech. To capture a complete 125-year history of an institution is impossible, but you may find here a glimpse of the Tech that years have removed from the memories of many. In so doing, you may discover and appreciate the legacy of those students, faculty, and administrators who have shaped the Virginia Tech of today.

Nelson Harris
Roanoke, Virginia

One

THE EARLY YEARS

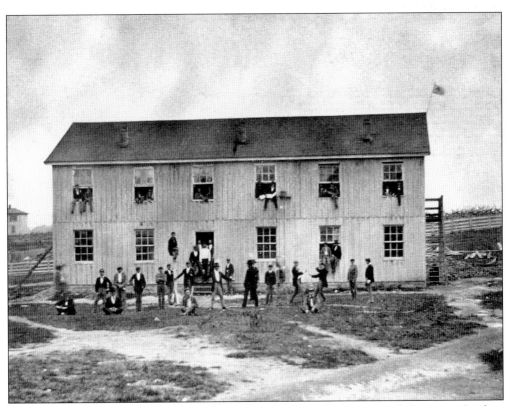

Students pose for this *c.* 1870s image of "Dutch Alley" that contained shops on the first floor and dormitory rooms on the second floor. This was one of the earliest buildings used by Virginia Tech. (DLA/University Libraries, VPI&SU.)

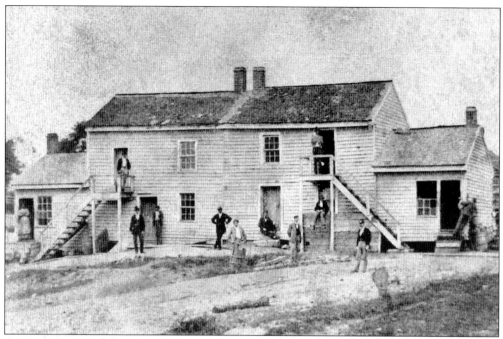

The Mess Hall opened in 1874 and was located in the vicinity of present-day Price Hall. This photograph is dated the year it opened. (DLA/University Libraries, VPI&SU.)

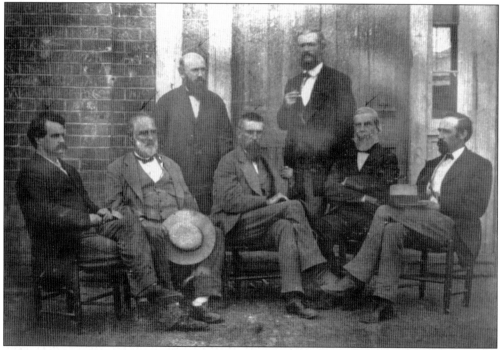

This photograph shows some of the early faculty members for the Virginia Agricultural and Mechanical College. Seated from left to right are President Minor, Charles Martin, M.G. Ellzey, V.E. Shepherd, and Gray Carroll. Standing are J.H. Lane at left and W.R. Boggs at right. (DLA/University Libraries, VPI&SU.)

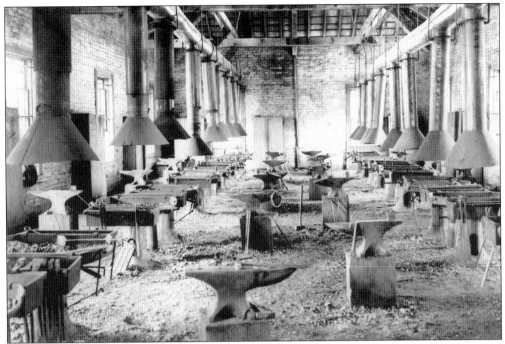

Given the early mission of the Virginia Agricultural and Mechanical College, students were schooled in a number of trades. This c. 1890s image shows the forge. (DLA/University Libraries, VPI&SU.)

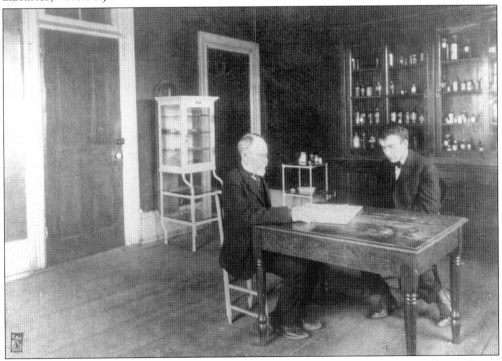

Dr. William Henderson, at left, is shown with an unidentified professor in the college's early infirmary c. 1890. (DLA/University Libraries, VPI&SU.)

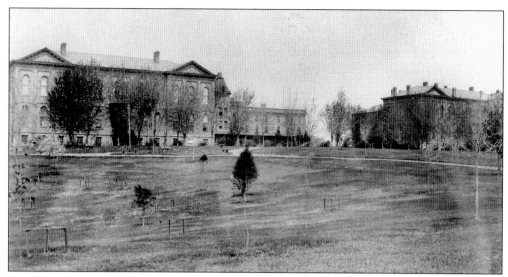

This is a view of the college's campus in 1894. This photograph shows Academic Buildings Numbers One and Two, in the background, and Barracks Numbers One and Two. (DLA/University Libraries, VPI&SU.)

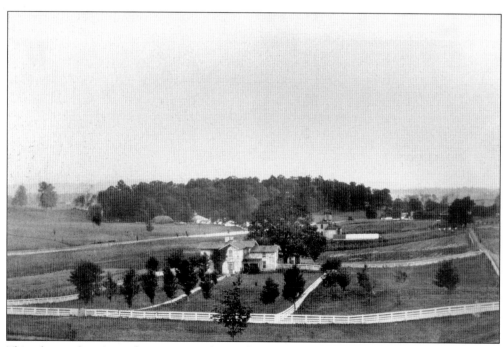

This shows the view of campus in the early 1890s as one looked west from Academic Building Number Two. (DLA/University Libraries, VPI&SU.)

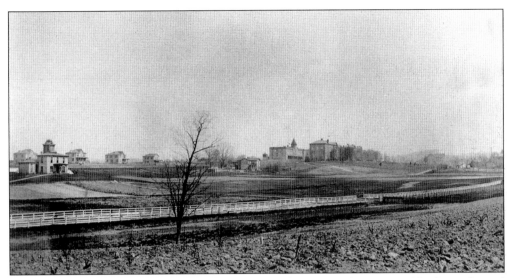

Here is the college's campus as it looked in the 1894–1895 academic year. The barracks and academic buildings are located on the knoll to the right. The houses in the background are faculty row. (DLA/University Libraries, VPI&SU.)

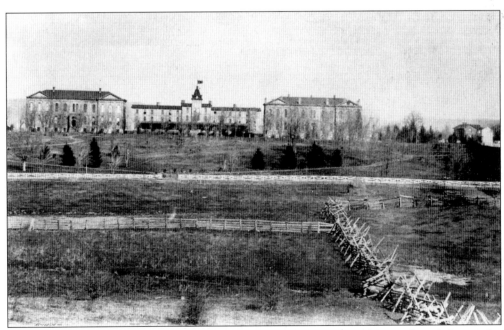

This is another view of the college campus in 1894–1895. The buildings, from left to right, are Academic Building Number Two, Barracks Number One, Academic Building Number One, and the Commandant's quarters. (DLA/University Libraries, VPI&SU.)

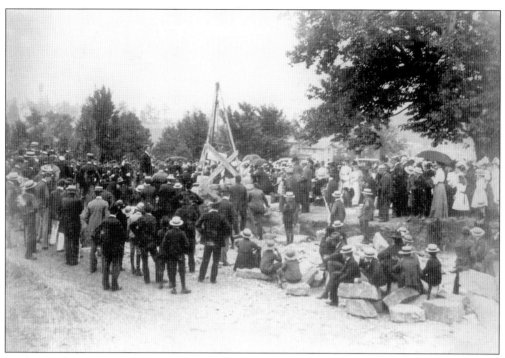

As the student body grew, so too did the campus. In 1898, the cornerstone was placed for the new YMCA building. (DLA/University Libraries, VPI&SU.)

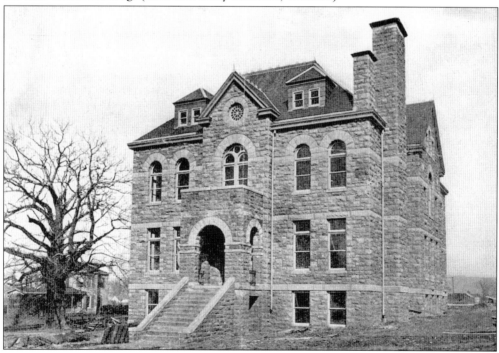

Here is the YMCA building just a few years after its construction, *c.* 1900. For many years, student cadets were entertained by the weekly showing of silent films on the second floor. (DLA/University Libraries, VPI&SU.)

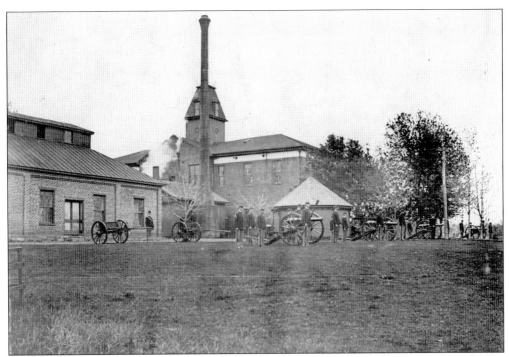

This *c.* 1895 image shows Barracks Number One in center, the commons, and cadets in formation with cannons. (DLA/University Libraries, VPI&SU.)

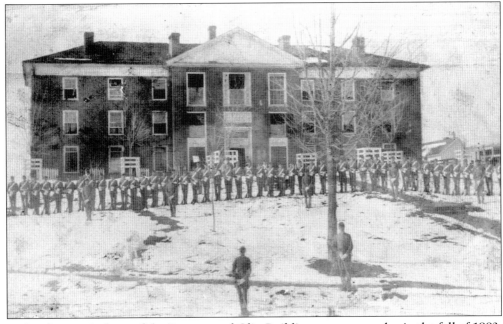

Cadets line up in front of the Preston and Olin Building on a snowy day in the fall of 1883. This building was originally part of the Preston and Olin Institute of Blacksburg, an early Methodist academy. (DLA/University Libraries, VPI&SU.)

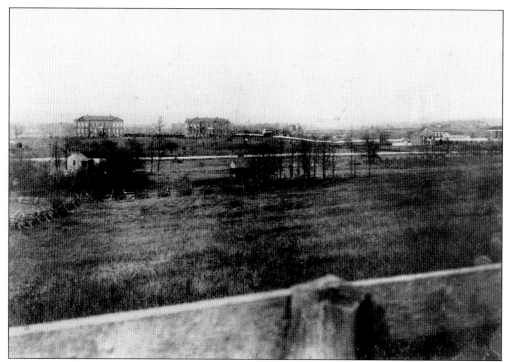

This is yet another very early view of the college, *c.* 1880. The buildings have been identified as, from left to right, Academic Building Number Two, the Commandant's quarters, the President's house, the pavilion and shops, and the Preston-Olin Building. (DLA/University Libraries, VPI&SU.)

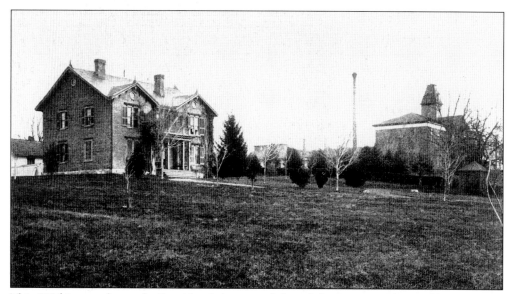

This 1894 image shows the President's house at left and the Preston-Olin Building at right. (DLA/University Libraries, VPI&SU.)

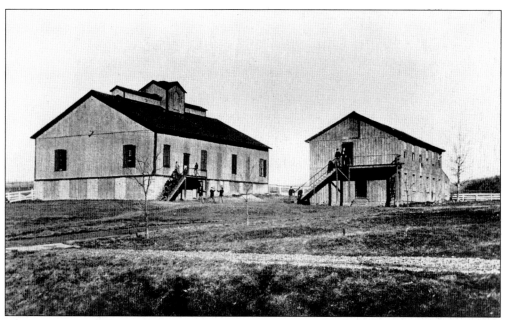

Here are the pavilion and shops known as Dutch Alley, *c.* 1879. The pavilion, at left, was constructed during the summer of 1879. (DLA/University Libraries, VPI&SU.)

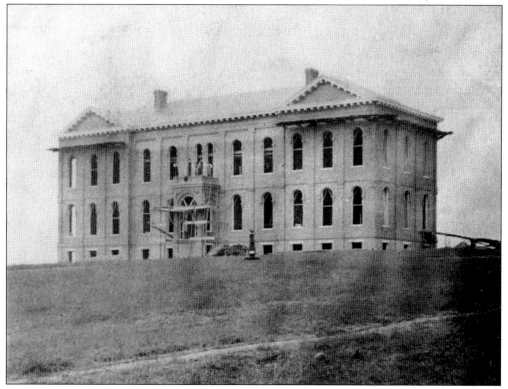

The second academic building, under construction in this image, was built during the 1876–1877 academic year. This building was razed in the late 1950s to make room for Brodie Hall. (DLA/University Libraries, VPI&SU.)

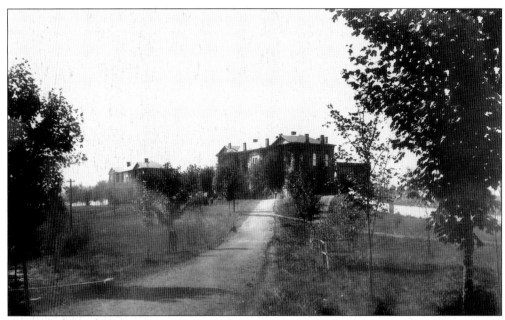

This 1895 view shows the academic buildings as viewed from the Mess Hall. (DLA/University Libraries, VPI&SU.)

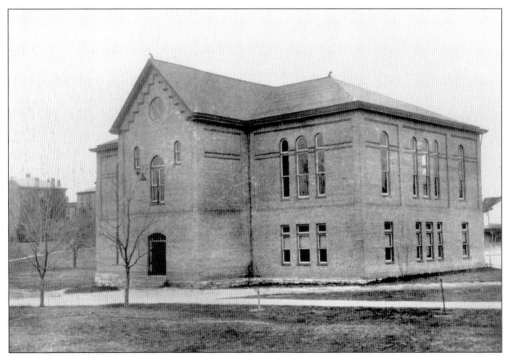

Mess and commencement halls, *c.* 1895, were main points of cadet life. One cadet described the fare served here as "tough beef and cold potatoes in the fall, cold potatoes and tough beef in the winter, and both at the same time in the spring." This building, also known as German Hall, was razed in 1955. (DLA/University Libraries, VPI&SU.)

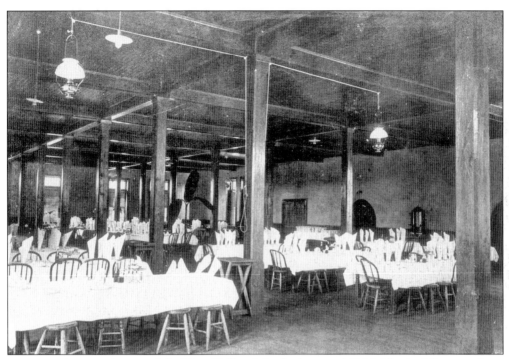

Here is an interior image of the Mess Hall as it looked around 1900. The building was later converted to classrooms. (DLA/University Libraries, VPI&SU.)

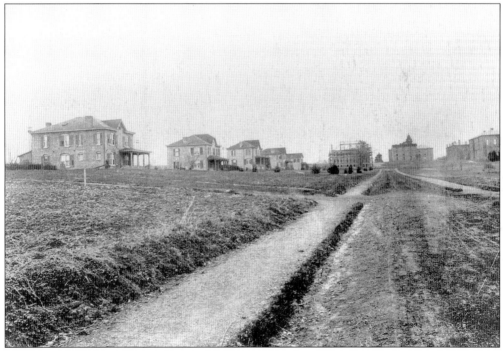

This row of houses is Faculty Row; it led to the campus's quadrangle. This photo, dated 1899–1900, appears to show a building near the quad under construction. (DLA/University Libraries, VPI&SU.)

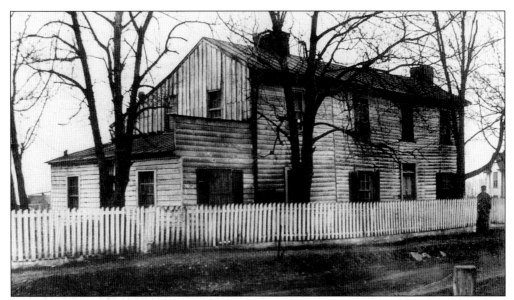

Known as the Effinger House, and also called "Noah's Arks," this home was purchased by the college, renovated, and used as the school's first infirmary. The picture is *c.* 1890. (DLA/University Libraries, VPI&SU.)

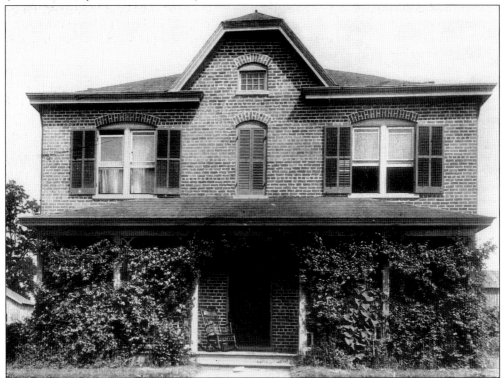

Saint's Rest was one of the homes along Faculty Row and served as quarters for Prof. Ellison A. Smyth when this image was taken in the 1890s. While the college provided faculty housing, many professors complained that it created a "pecking order." The last-standing homes on Faculty Row were removed in 1960. (DLA/University Libraries, VPI&SU.)

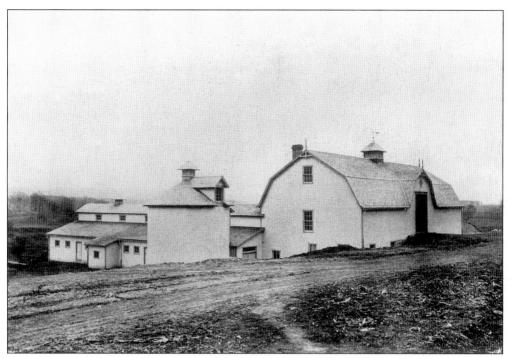

The college barn was the forerunner of many agricultural buildings that would emerge. This image is from 1899. The barns were located in the parking area west of the coliseum. (DLA/University Libraries, VPI&SU.)

The original Horticultural Hall is shown in this photograph from 1899. (DLA/University Libraries, VPI&SU.)

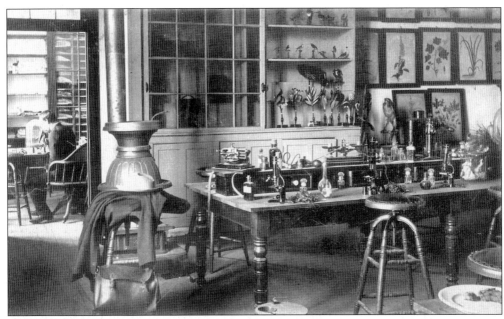

Prof. G.F. Atkinson can be seen at work through the doorway at left. The foreground shows the biology classroom of 1888. (DLA/University Libraries, VPI&SU.)

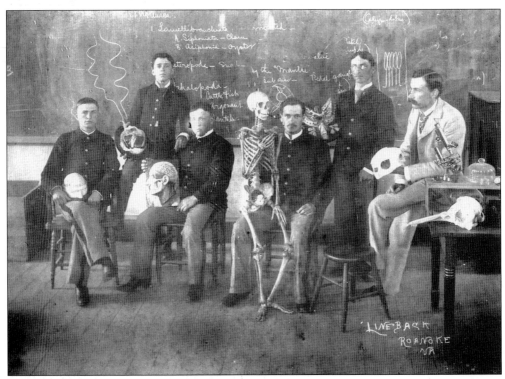

If you were a student in 1892 and enrolled in the anatomy class, you would have been in this picture! Students surround Prof. E.A. Smyth, who is on the far right. (DLA/University Libraries, VPI&SU.)

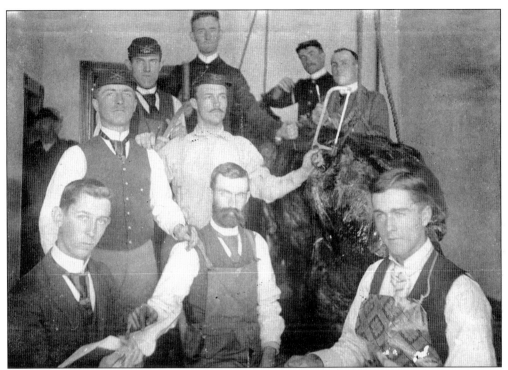

The veterinary class of 1893 poses for a photograph. (DLA/University Libraries, VPI&SU.)

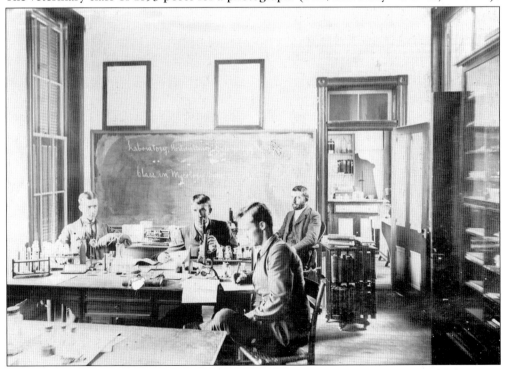

This 1891 image show a mycology class meeting in the school's horticultural lab. (DLA/University Libraries, VPI&SU.)

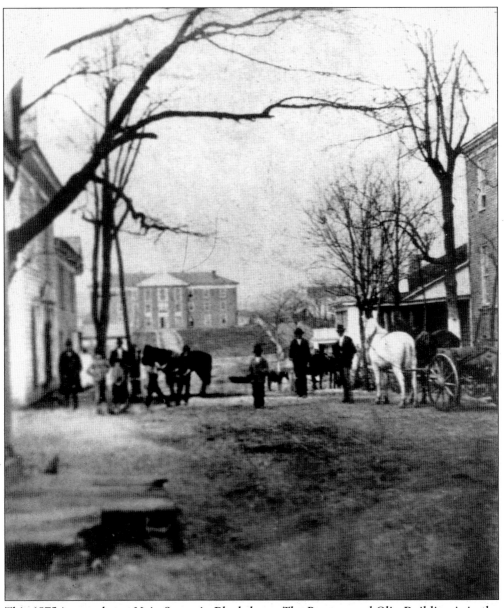

This 1875 image shows Main Street in Blacksburg. The Preston and Olin Building is in the center background. (DLA/University Libraries, VPI&SU.)

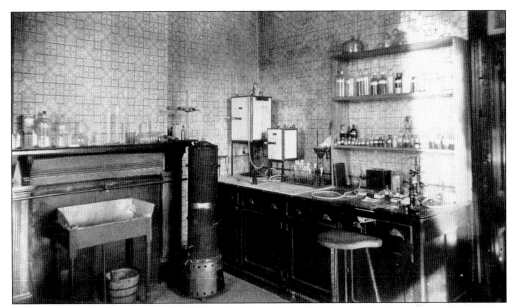

This is an early laboratory, possibly for veterinary class, as photographed in 1895. (DLA/University Libraries, VPI&SU.)

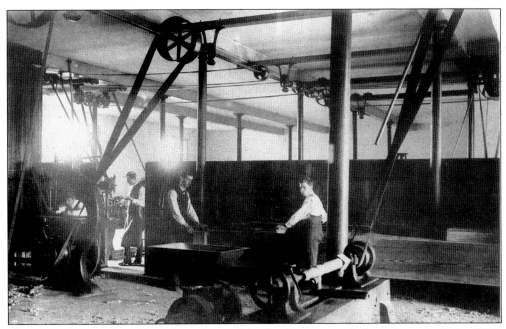

This was the woodworking shop, located in the basement of the science hall, in 1893. (DLA/University Libraries, VPI&SU.)

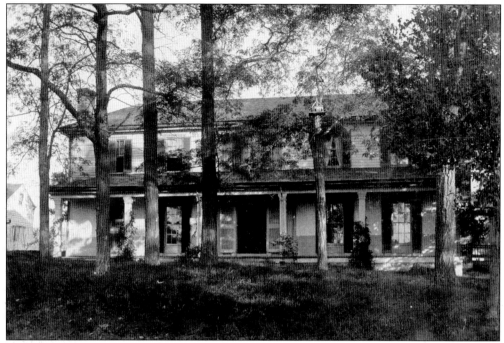

One of the oldest structures still on the Tech campus is Solitude. Here is how the home looked in the 1890s. (DLA/University Archives, VPI&SU)

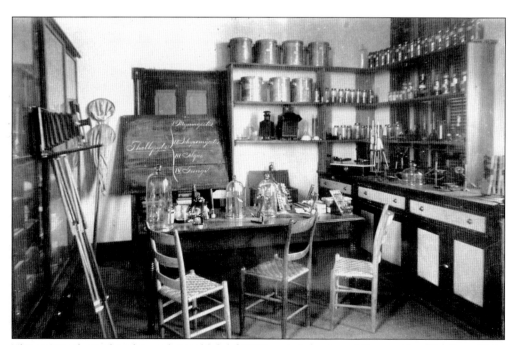

The entomological and mycological lab of 1895 certainly served the needs of its time. Note the nets and camera on the left. (DLA/University Libraries, VPI&SU.)

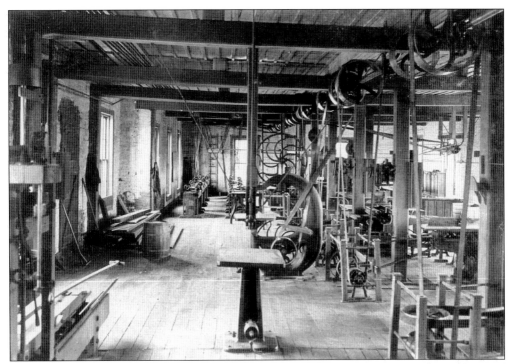

The interior of the machine shop is shown in this 1895 photograph. (DLA/University Libraries, VPI&SU.)

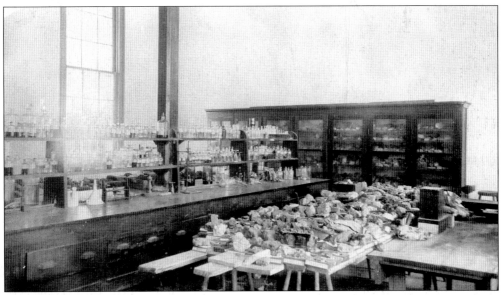

Rocks stacked on a table denote a mineralogical lab in this 1895 photograph. (DLA/University Libraries, VPI&SU.)

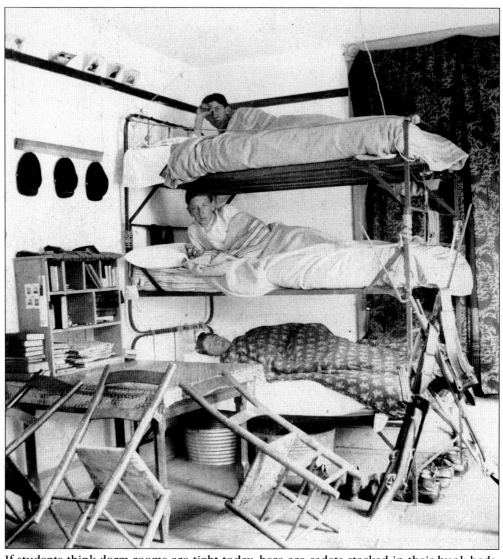

If students think dorm rooms are tight today, here are cadets stacked in their bunk beds, *c.* 1890. (DLA/University Libraries, VPI&SU.)

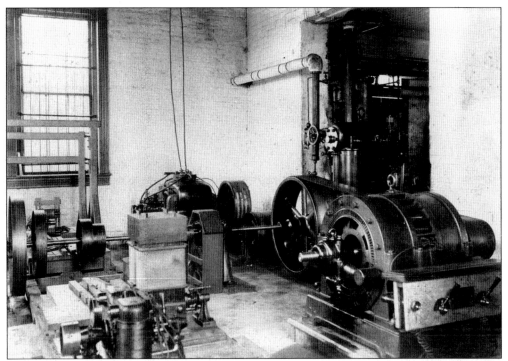

This image from 1896–1897 shows the dynamo room in the department of physics and engineering. (DLA/University Libraries, VPI&SU.)

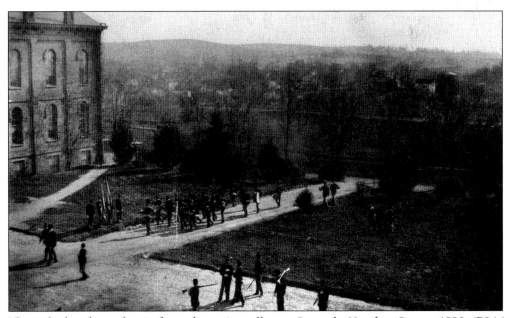

The cadet band marches in from the main walk near Barracks Number One, *c.* 1890. (DLA/ University Libraries, VPI&SU.)

Students in a dorm room have made a tent with a "guard" posted above the entrance. (DLA/University Libraries, VPI&SU.)

Two

CADET LIFE

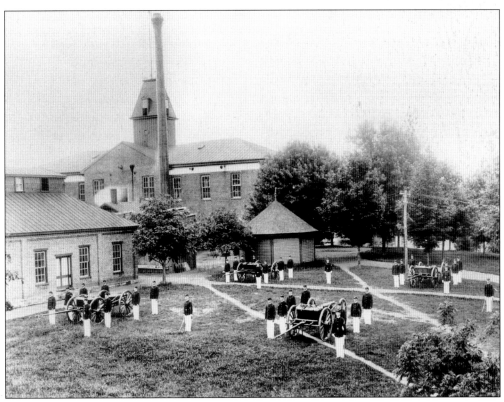

Battery E stands in formation for a gun drill in this photograph taken in May 1896. (DLA/ University Libraries, VPI&SU.)

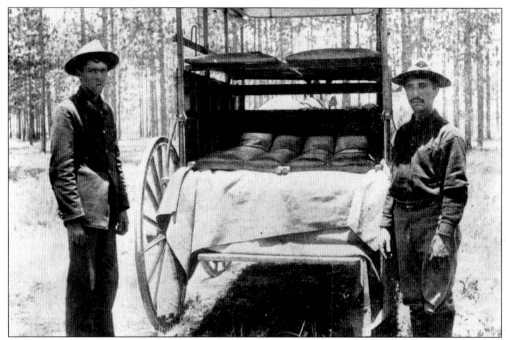

During a military training exercise in the 1890s, these cadets pose at an ambulance wagon, giving an indication of the primitive means of military operations compared to the standards of today. (DLA/University Libraries, VPI&SU.)

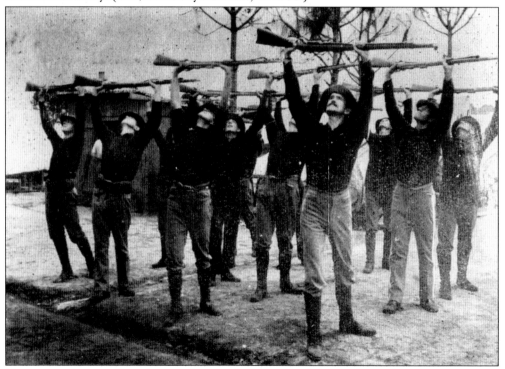

This image shows cadets doing military calisthenics with Springfield rifles, *c.* 1890s. (DLA/University Libraries, VPI&SU.)

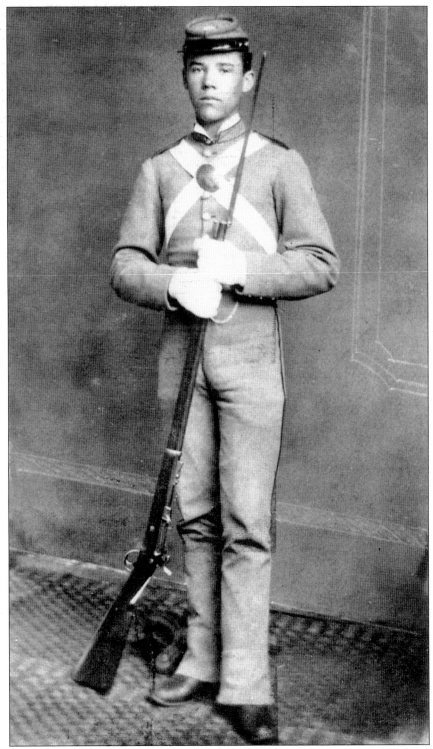

Here is an unidentified Virginia Mechanical and Agricultural College cadet posing in uniform in 1872. (DLA/University Libraries, VPI&SU.)

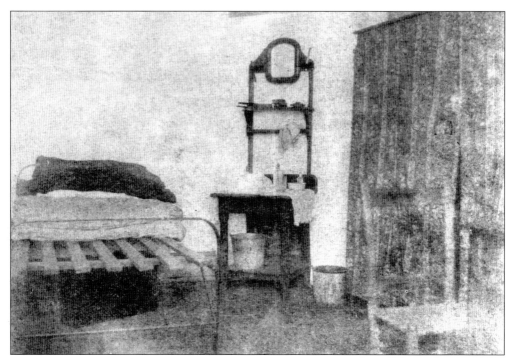

A cadet may have easily missed the comforts of home when he found his barracks room. Here is a room from 1896 as it existed in Barracks Number One. Note the bed frame and slats with a very thin mattress. (DLA/University Libraries, VPI&SU.)

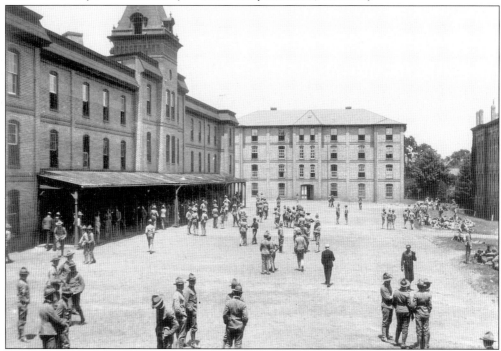

Cadets mingle in the quadrangle in front of Barracks Number One, at left, in this photograph dated 1907. (DLA/University Libraries, VPI&SU.)

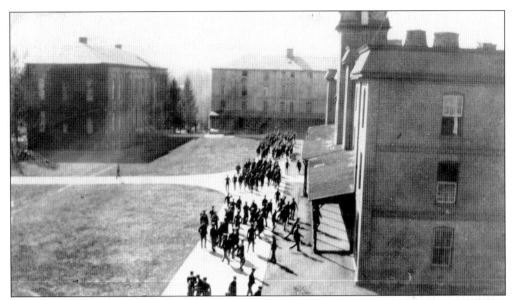

Here is another image of the quadrangle surrounded by barracks and academic buildings, with cadets possibly changing classes. This photograph was taken during the 1917–1918 academic year. (DLA/University Libraries, VPI&SU.)

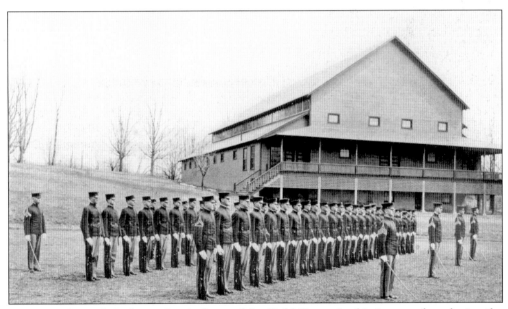

Company C stands in formation in front of the Field House in this image taken during the 1914–1915 academic year. (DLA/University Libraries, VPI&SU.)

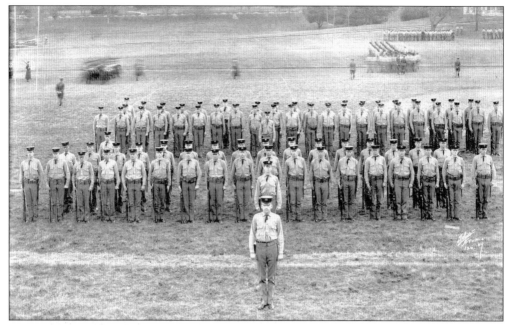

Company A, in formation on the drill field, is captured in this yearbook photograph from the 1923–1924 academic year. (DLA/University Libraries, VPI&SU.)

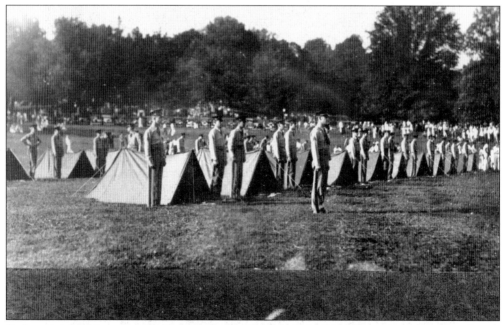

Cadets engaged in a variety of military demonstrations during Commencement weekend. This 1934 image shows cadets pitching shelter halves on the drill field. (DLA/University Libraries, VPI&SU.)

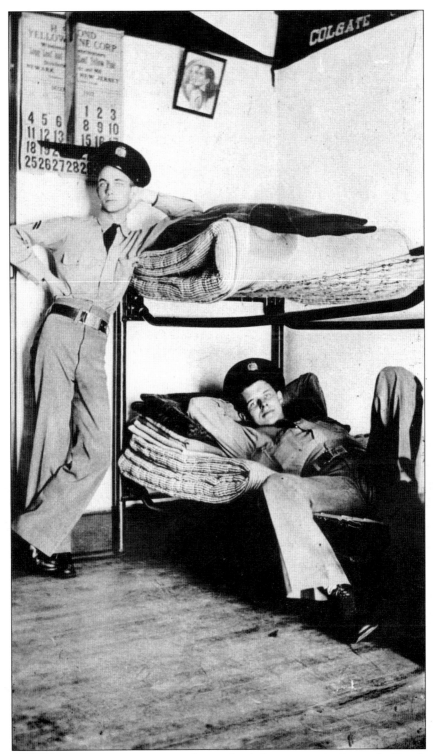

Unidentified cadets from Company E relax in their dorm room in Barracks Number Four in this 1933 image. (DLA/University Libraries, VPI&SU.)

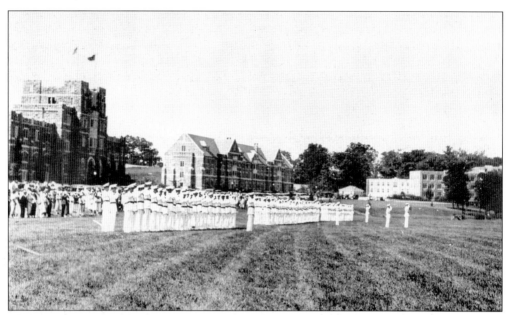

Cadets are in formation on the drill field for the commissioning ceremony that occurred during Commencement in 1934. (DLA/University Libraries, VPI&SU.)

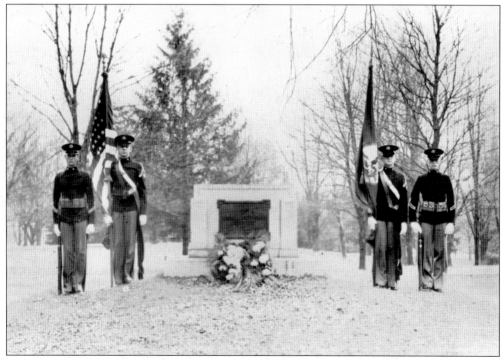

The cadet Honor Guard stands at the World War I Memorial on the Tech campus in this image dated May 11, 1931. The memorial was erected by the Class of 1919 to "Our Dead Heroes Over There." (DLA/University Libraries, VPI&SU.)

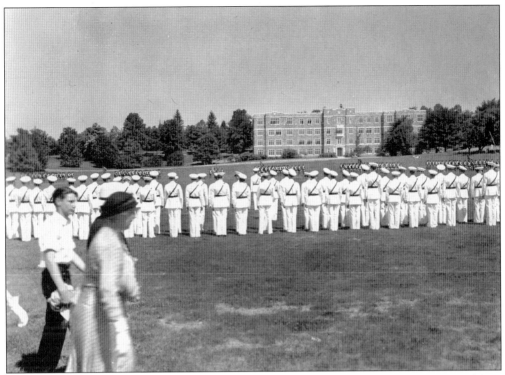

This is another image of cadets as they are in formation on the drill field for the Commissioning Ceremony of 1934. (DLA/University Libraries, VPI&SU.)

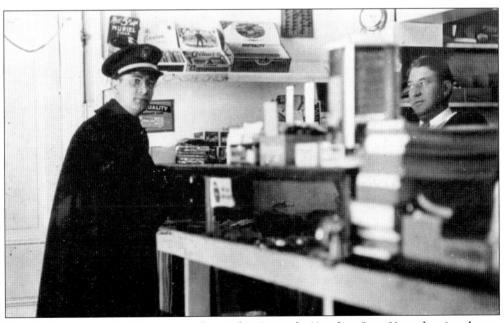

Here is the campus bookstore once located in Barracks Number One. Note the cigar boxes above the cadet. Joe Crabbs is on the left and Earl Linkous, the assistant manager of the store, is on the right. The photo is dated 1933. (DLA/University Libraries, VPI&SU.)

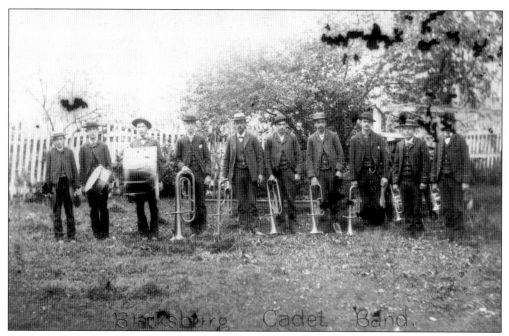

What would a military company be without a cadet band? The only two members identified are Eustis Lancaster, second from left, and Arthur Lancaster, fourth from left. This photo was taken on May 3, 1884. (DLA/University Libraries, VPI&SU.)

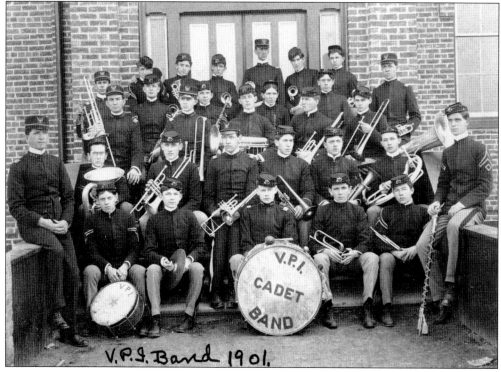

As the drum canvas denotes, this is the VPI Cadet Band from 1901. (DLA/University Libraries, VPI&SU.)

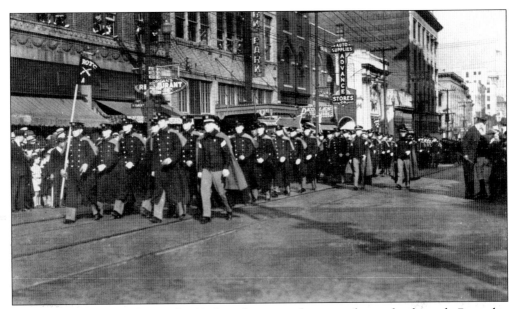

One of the great traditions for Tech cadets was the annual parade through Roanoke, Virginia, on Thanksgiving Day. The parade took place in advance of the football game against Virginia Military Institute, played at Victory Stadium. Here the cadets march through Roanoke's downtown on Thanksgiving Day, 1933. (DLA/University Libraries, VPI&SU.)

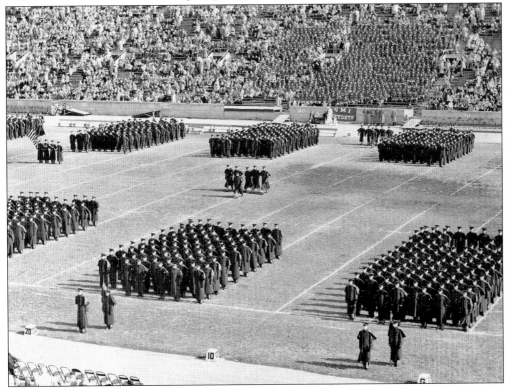

The cadets are seen on the field in Victory Stadium at Roanoke, Virginia, for the VPI-VMI football game on Thanksgiving Day, 1956. (DLA/University Libraries, VPI&SU.)

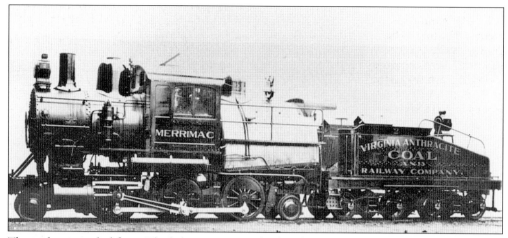

The cadets traveled from Blacksburg to Roanoke for the annual football game on the train affectionately known as the *Huckleberry*. Some say it got that name because the train moved so slow uphill that cadets could dismount the train, pick berries, and then get back on! Here is a photo identified as the first *Huckleberry*, Engine No. 2, from 1904. (DLA/ University Libraries, VPI&SU.)

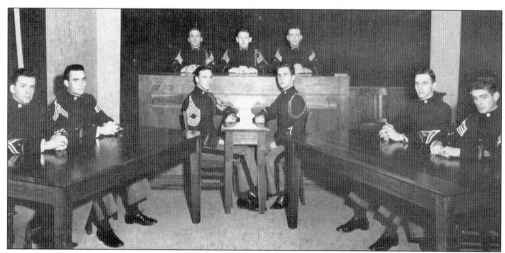

To enforce discipline and military values the cadet corps developed an honor court. Here is the court from 1949–1950. The cadet corps' court was established in 1908, and a civilian student court was developed in 1941. (DLA/University Libraries, VPI&SU.)

The cadet band eventually came to be known as the "Highty Tighties." Here the band is on the Tech drill field in 1958. (DLA/University Libraries, VPI&SU.)

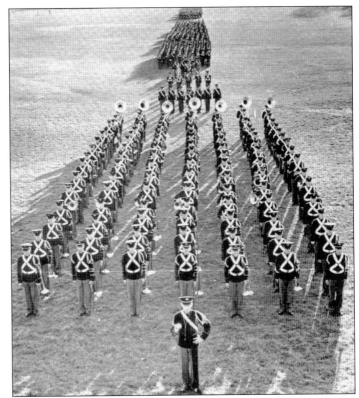

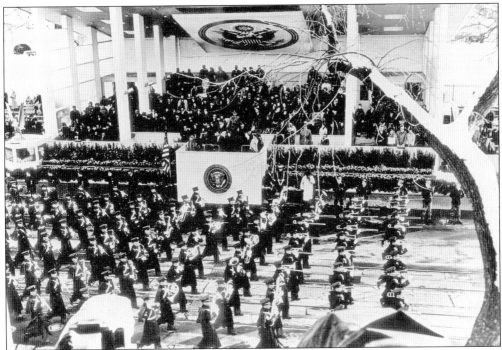

The Tech cadet band had the honor of marching in the inauguration parade for President John F. Kennedy in 1961. (DLA/University Libraries, VPI&SU.)

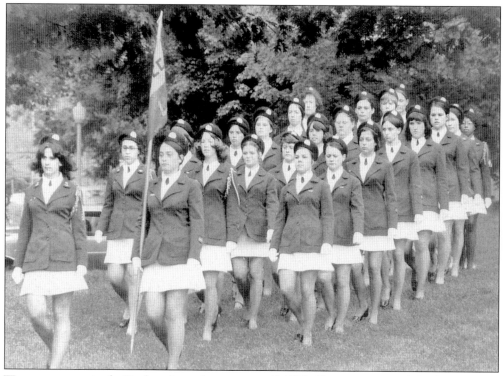

Women were not admitted to the cadet corps until 1973. Here are some of the first women cadets in the 1973–1974 academic year. (DLA/University Libraries, VPI&SU.)

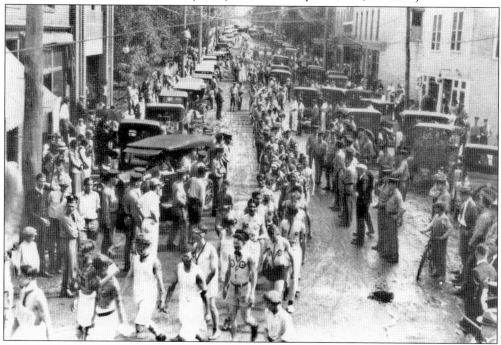

One of the early hazing traditions for cadets was the rat parade of freshmen. Here the rat parade marches through Blacksburg in 1923. (DLA/University Libraries, VPI&SU.)

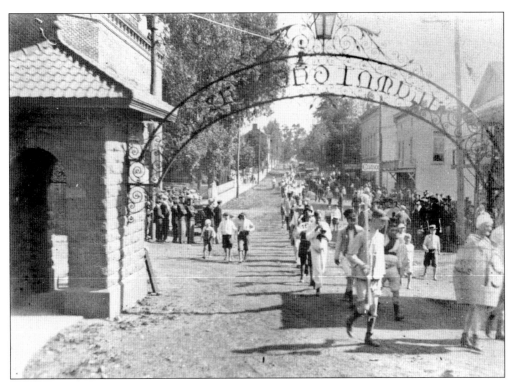

The rat parade of 1915 marches through Alumni Gate on the Tech campus having come through Blacksburg. (DLA/University Libraries, VPI&SU.)

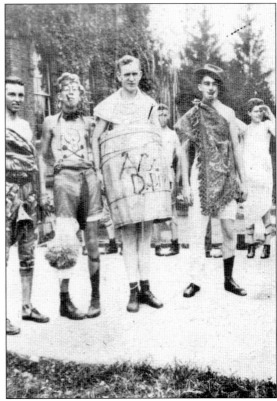

Some rats are appropriately attired for participation in the rat parade in this photograph from the 1920s. (DLA/University Libraries, VPI&SU.)

Rats are ready for their parade to start. In the age of political incorrectness, rats often dressed in female garb, as is the case with rat "couple" in the center. This image is from the 1920s. (DLA/University Libraries, VPI&SU.)

Another ritual endured by rats was the "mattress throw." For this storied event, sophomores would enter the freshmen's dorm rooms and toss their mattresses out the windows. Freshmen would retrieve them and return them to the rooms. This usually occurred to mark the start of the school year. (DLA/University Libraries, VPI&SU.)

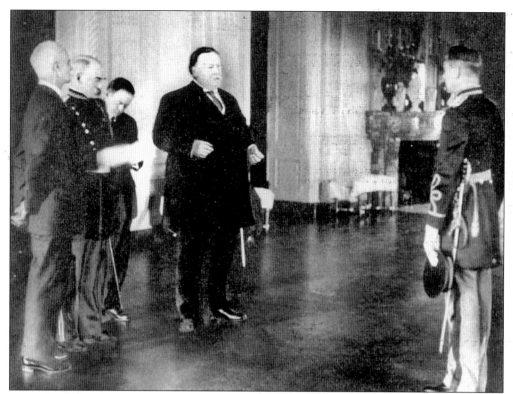

Julien E.V. Gaujot (class of 1893) receives the Medal of Honor from President William Howard Taft at a White House ceremony in 1912. Virginia Tech has has six other Medal of Honor recipients: Antoine Gaujot (class of 1900), Earle Gregory (class of 1923), James Montieth Jr. (class of 1941), Herbert Thomas (class of 1941), Robert Femoyer (class of 1944), and Richard Shea Jr. (class of 1998). (DLA/University Libraries, VPI&SU.)

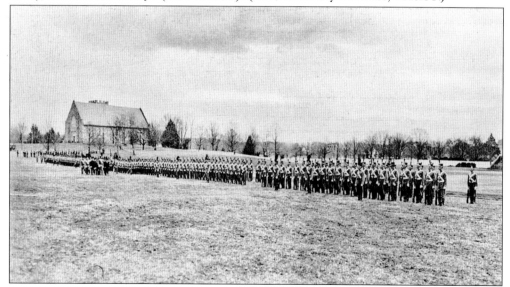

Virginia governor William Mann inspects the cadet battalion on the drill field in this image from 1911. (DLA/University Libraries, VPI&SU.)

Three

ATHLETICS

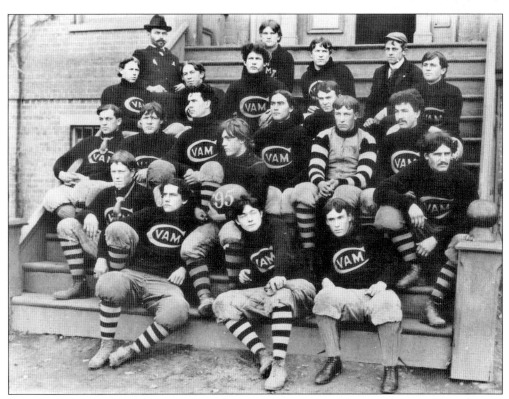

The football team of 1895, pictured here, was the first team to beat Virginia Military Institute. The insignia on the jerseys stands for Virginia Agricultural and Mechanical College, the original name for Virginia Tech. (DLA/University Libraries, VPI&SU.)

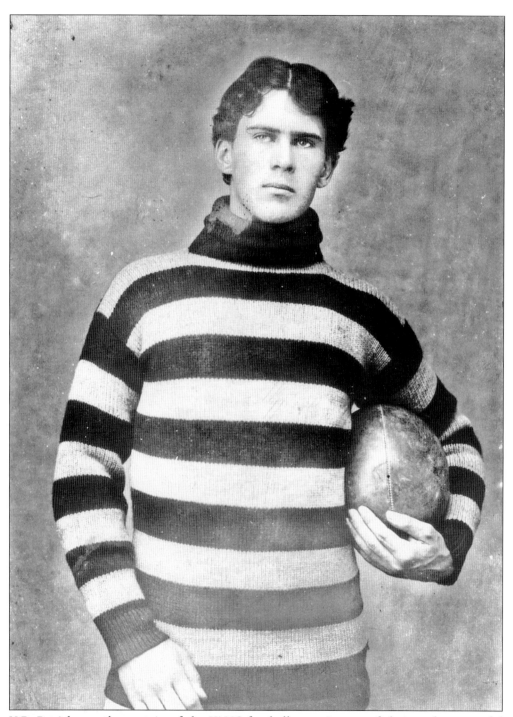

N.R. Patrick was the captain of the VAMC football team in one of their early successful seasons in 1895. Faculty and students engaged in the first-recorded game of football in the fall of 1891. (DLA/University Libraries, VPI&SU.)

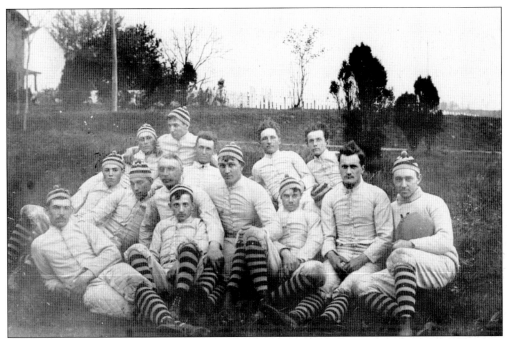

Shown here is the first football team to play for Virginia Tech, then Virginia Agricultural and Mechanical College, in 1892. The captain was Professor Anderson, and school colors were black and gray. And so much for helmets! (DLA/University Libraries, VPI&SU.)

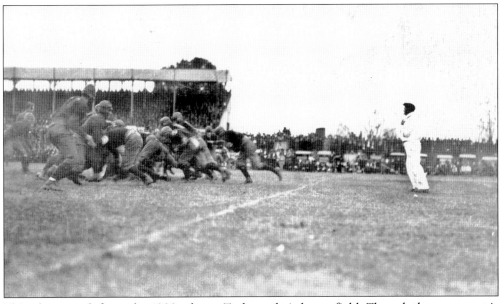

This photograph from the 1920s shows Tech on their home field. Though the opponent is unidentified, one should note the bleachers and the Fords on the sideline. (DLA/University Libraries, VPI&SU.)

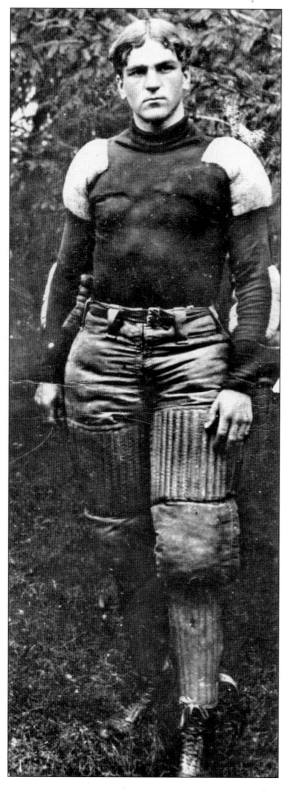

One of the early football standouts to play for Tech was Hunter Carpenter. Carpenter was elected to the National Football Hall of Fame in 1957, becoming the first football player from the school named to a national hall of fame. The image at left was taken in 1905, when he was playing for Tech. (DLA/University Libraries, VPI&SU.)

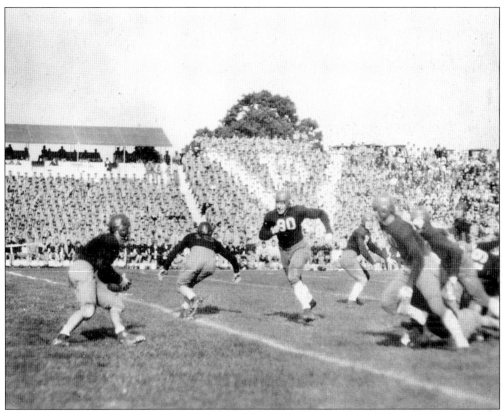

Here Tech plays an opponent on Miles Field in 1932. Note the cadets in the stands have outlined a white VP. (DLA/University Libraries, VPI&SU.)

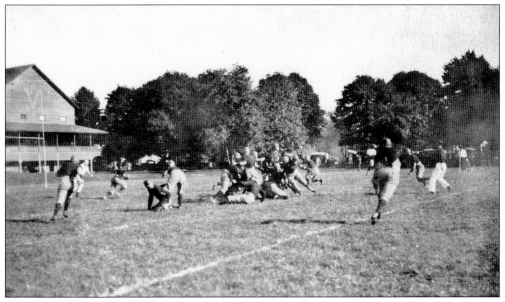

Tech takes the field against an opponent on Miles Field in the 1920s. (DLA/University Libraries, VPI&SU.)

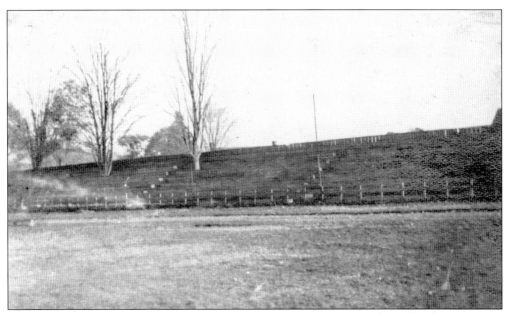

The football stadium was definitely lacking in comparison to the athletic venues on the campus today. Here are the bleachers from Miles Field in the 1920s. Note the trees protruding through—perhaps to provide a few shaded seats? (DLA/University Libraries, VPI&SU.)

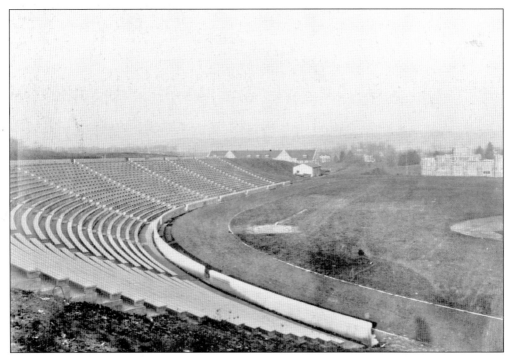

By the next decade Miles Field had become Miles Stadium, providing a better venue for Tech sports. This image was taken in 1932. (DLA/University Libraries, VPI&SU.)

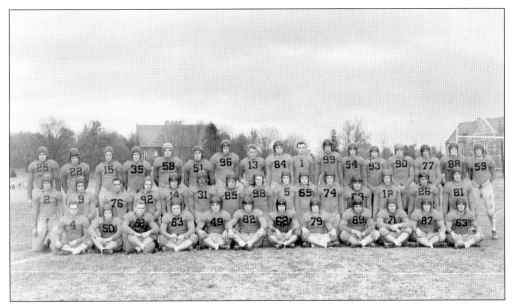

Here is the formal photograph of the football team from the 1941–1942 academic year. (DLA/University Libraries, VPI&SU.)

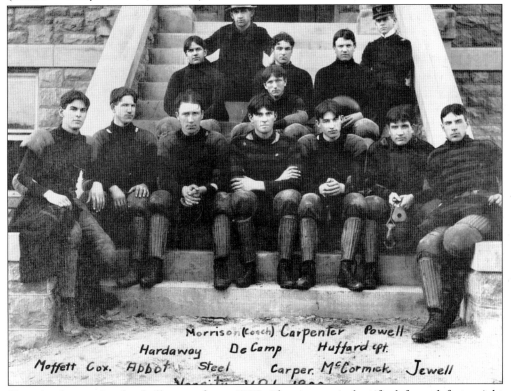

Here is the varsity football team from 1900. Players are indentified from left to right as follows: (front row) Moffett, Cox, Abbott, Steel, Carper, McCormick, and Jewell; (back row) Hardaway, Morrison, DeCamp, Carpenter, Huffard, and Powell. (DLA/University Libraries, VPI&SU.)

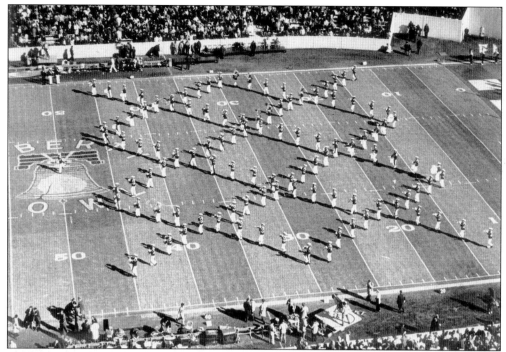

The cadet band marches at the 1969 Liberty Bowl. Unfortunately, VPI lost to Mississippi, 34-17. (DLA/University Libraries, VPI&SU.)

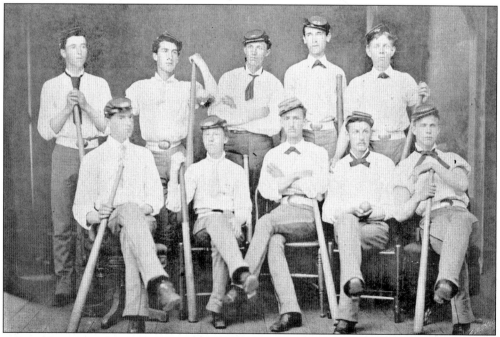

Before there was football, Tech had baseball. Shown here in 1876 is the school's first baseball team, also known as the Alleghany Baseball Club. The team is, from left to right, (front row) Taylor, S.S. Smith, C. Fry, P. Shepherd, and Lindsay; (back row) R.F. Respess, C.F. Handy, Lawson, and L.F. Kilby. (DLA/University Libraries, VPI&SU.)

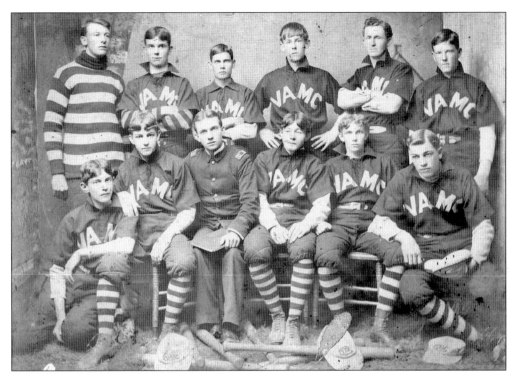

The baseball squad for Tech, then VAMC, posed for their team picture in the 1890s. Note the stripes! The first baseball game played by Tech was in 1877 against Roanoke College. Tech won 53-13. The margin of victory still stands as a school record. (DLA/University Libraries, VPI&SU.)

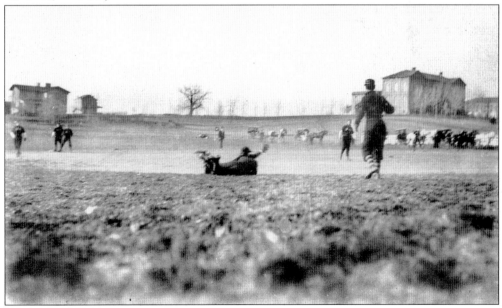

The photographer managed to capture the action at a Tech baseball game in 1893. The early campus is on the knoll to the right. A few spectators have come with horse and carriage. (DLA/University Libraries, VPI&SU.)

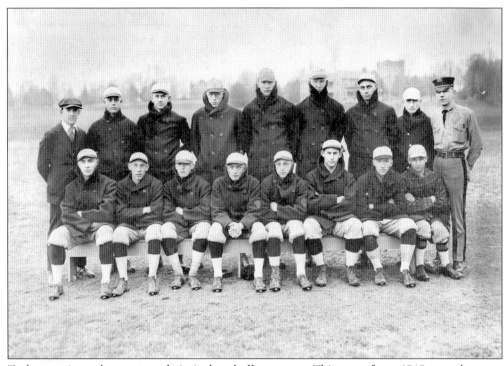

Tech experienced success early in its baseball program. This team from 1918 won the state championship. (DLA/University Libraries, VPI&SU.)

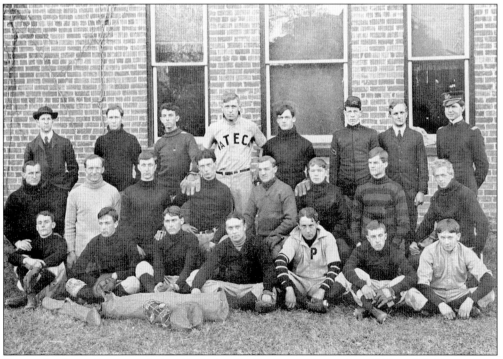

Pictured above is one of the Tech baseball teams from the 1920s. (DLA/University Libraries, VPI&SU.)

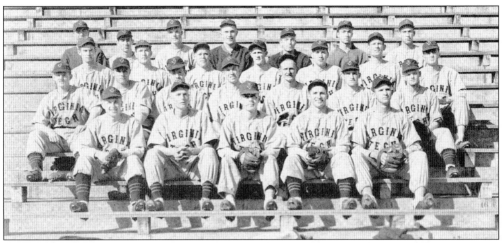

The Virginia Tech baseball team of 1948 posed for this photograph that appeared in *The Bugle*, Virginia Tech's yearbook. (DLA/University Libraries, VPI&SU.)

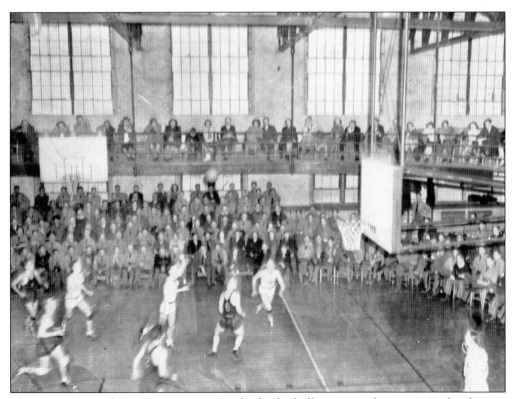

The War Memorial Gymnasium contained a basketball court, and Virginia Tech takes on an unidentified opponent in this image from 1933. Basketball was inaugurated at Tech in 1908. (DLA/University Libraries, VPI&SU.)

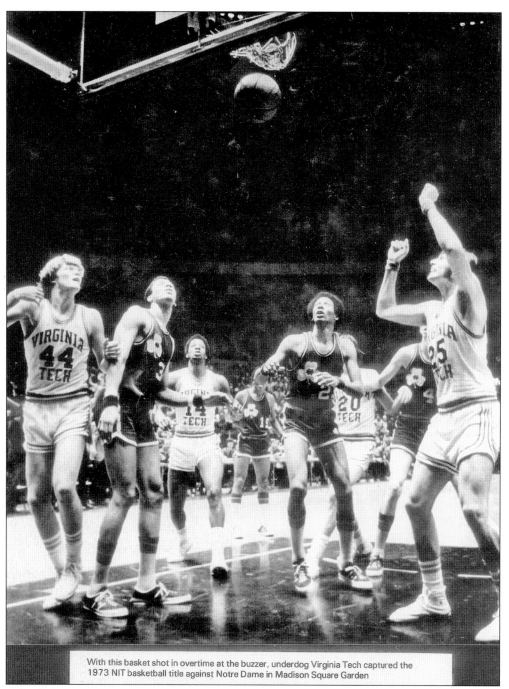

With this basket shot in overtime at the buzzer, underdog Virginia Tech captured the 1973 NIT basketball title against Notre Dame in Madison Square Garden

One of the greatest moments in Tech's athletic history came with this shot at the buzzer in overtime when underdog Virginia Tech defeated Notre Dame in the title game of the National Invitational Tournament, played at Madison Square Garden in 1973. (DLA/University Libraries, VPI&SU.)

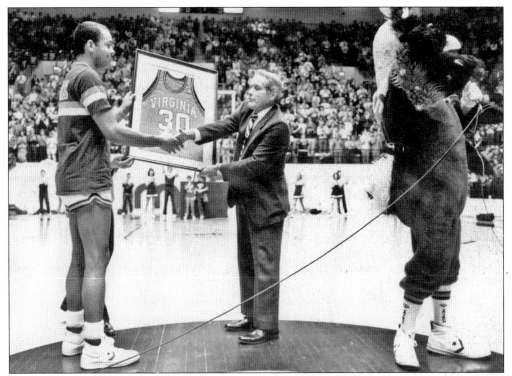

Dell Curry became the first Virginia Tech basketball player to have his jersey retired when the university honored him in a ceremony before his last game on March 1, 1986. (DLA/University Libraries, VPI&SU.)

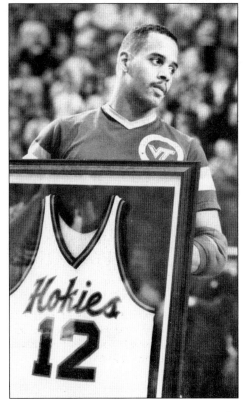

Virginia Tech guard Bimbo Coles became the second men's basketball player to have his jersey retired when the university honored him in a ceremony prior to his last game on March 3, 1990. (DLA/University Libraries, VPI&SU.)

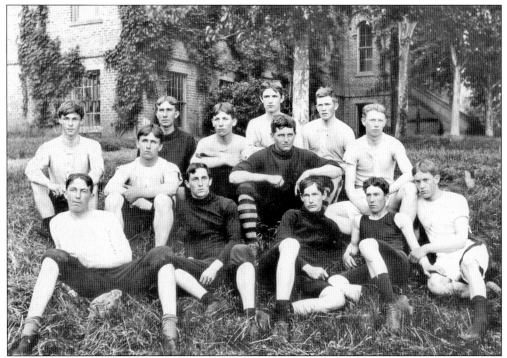

First came baseball and then football, and in 1896 the school put together its first track and field team, shown here. Track and field did not become an intercollegiate sport at Tech until 1906. (DLA/University Libraries, VPI&SU.)

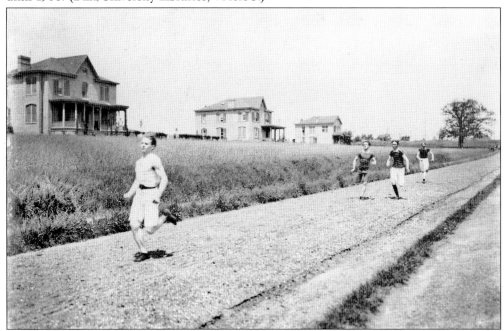

This track meet has students running past Faculty Row. This image is from the late 1890s, and the runners are students with the last names of, from left to right, Rorebeck, Crowley, Wilkins, and Bean. (DLA/University Libraries, VPI&SU.)

A student competes in a track and field event in 1898. Note the mattress for the pole-vaulter to cushion his fall. (DLA/University Libraries, VPI&SU.)

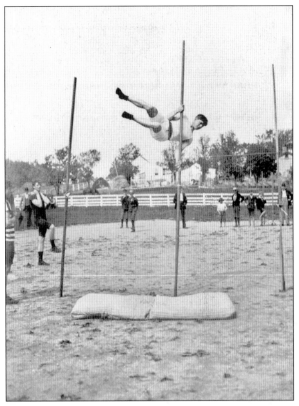

This track and field event occurred on the Tech campus in the 1890s. (DLA/University Libraries, VPI&SU.)

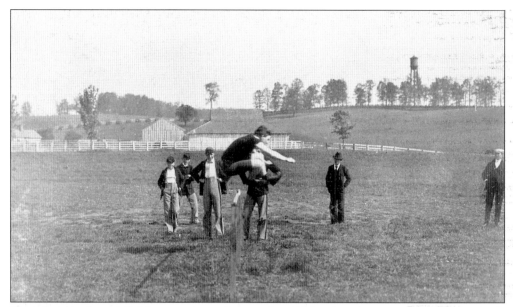

Here is a track and field event occurring in the 1890s. One has to wonder how much traction the runners could get competing on grass. (DLA/University Libraries, VPI&SU.)

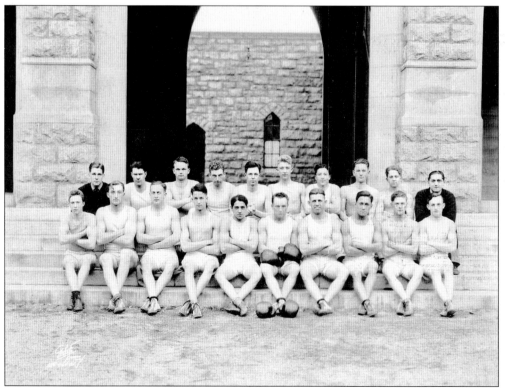

Here is the VPI boxing team of 1924. (DLA/University Libraries, VPI&SU.)

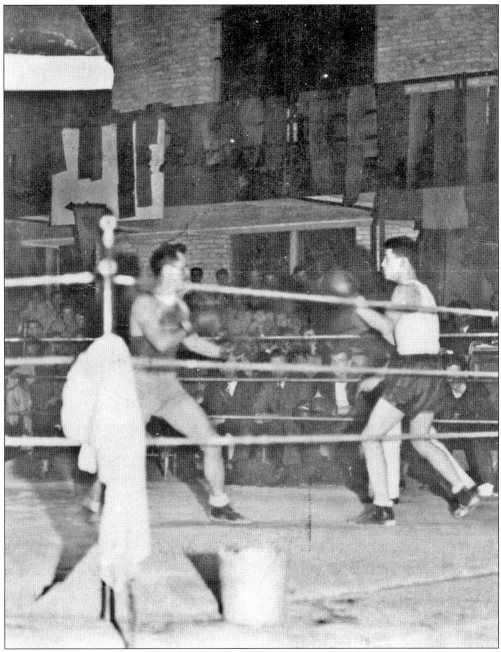

For a period of time in the mid-1920s and 1930s, boxing was a major sport at Tech. It was originally started independently by Roy Harman, class of 1926, and Karl Esleek, class of 1927. This 1933 photo shows a match between Tech and VMI, featuring Bussey versus Blackstone. (DLA/University Libraries, VPI&SU.)

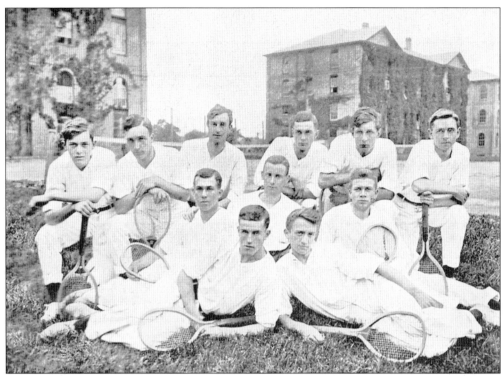

In 1891 a tennis association was formed at Tech, probably in connection with the development of a campus athletic association. Here is one of Tech's men's tennis teams of the 1930s. (DLA/University Libraries, VPI&SU.)

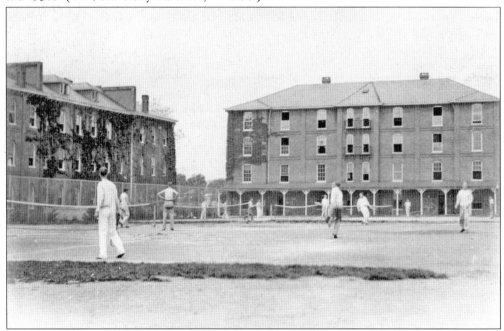

This 1933 image shows the tennis courts at Tech. Note the proper tennis attire is being worn—namely long pants. (DLA/University Libraries, VPI&SU.)

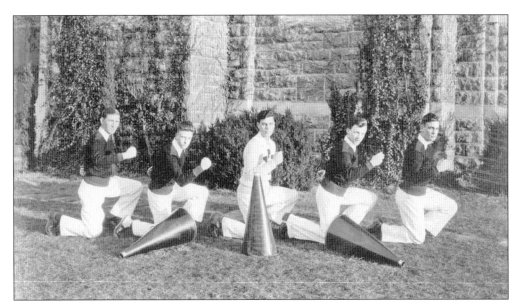

As athletics changed so did cheerleading. Above is the Tech cheerleading squad of 1933–1934. Pictured from left to right are Jimmy Taylor, Bill Sydnor, Garland Wood, Cecil Fuller, and Bob Fulton. (DLA/University Libraries, VPI&SU.)

Cheerleading is considered by many today to be a sport because of the athletic nature of the squads. Tech's first known college cheer was from the early 1890s and went "Rip Rah Ree! Va, Va, Vee! Virginia, Virginia! AMC." AMC stood for Agricultural and Mechanical College. Later the college cheer became, "Hokie, Hokie, Hokie, Hy! Tech! Tech! VPI! Sola-Rex-Sola-Rah, Polytech-Vir-gin-I-a! Rae, Ri, VPI!" (DLA/University Libraries, VPI&SU.)

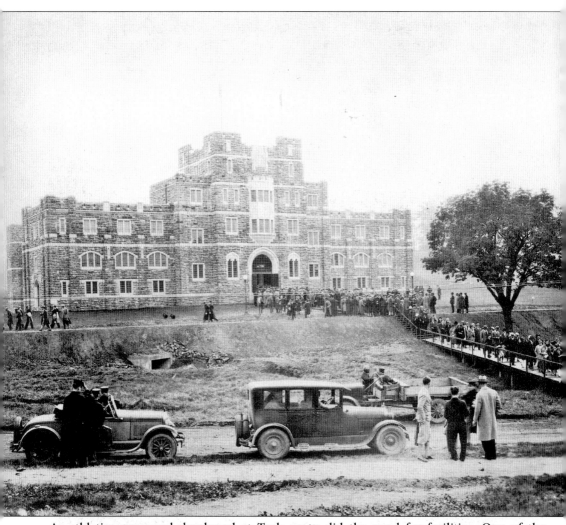

As athletics grew and developed at Tech so to did the need for facilities. One of the first significant capital investments made by the university for sports was the Memorial Gymnasium, completed in 1926 and shown here in the late 1920s. The photo is believed to be of a commencement ceremony. The first organized baseball game to be played by Tech was in 1877. Football followed in 1891, as did numerous other sports. Tech president John McBryde, who served the university from 1891 to 1907, was the first to stress the importance of student activities and athletics beyond the classroom. He converted some of the horticultural gardens into athletic fields, solicited donations for athletic equipment, made football a major sport at Tech, and presented the first plan for a manager of athletics position.

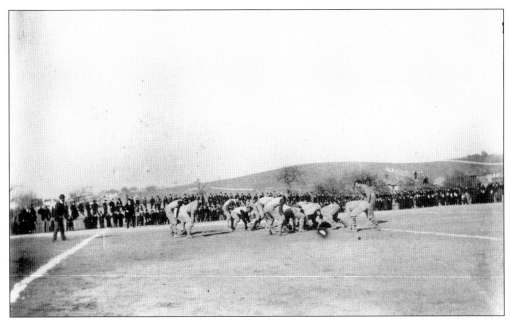

This image shows the very first VAMC-VMI football game, played on Thanksgiving Day in 1894. The game was played in Staunton, Virginia, and VAMC lost 10-6. This began a storied rivalry that lasted for decades. (DLA/University Libraries, VPI&SU.)

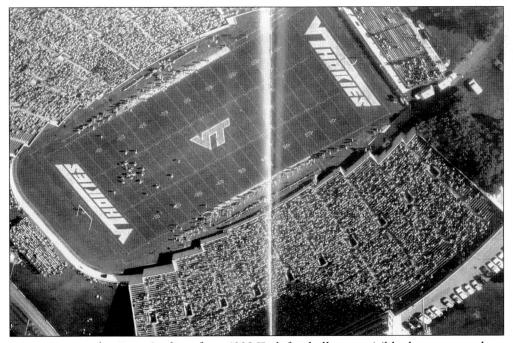

A capacity crowd at Lane Stadium for a 1992 Tech football game visibly demonstrates how far Tech athletics has come in the 100 years since cadets played the first pick-up football game in the quad fronting Barracks Number One. (DLA/University Libraries, VPI&SU.)

Cassell Coliseum (bottom left) was constructed in the early 1960s and brought renewed life and interest to the Tech basketball program. From 1954 to 1965, Tech invested heavily in athletic capital improvements: a new baseball field opened in 1954, a golf course in 1959, a coliseum in 1962, and tennis courts, a stadium, and an artificial-surface track in 1965. (DLA/University Libraries, VPI&SU.)

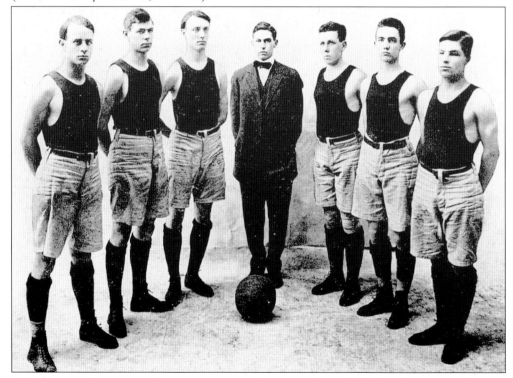

VPI's first varsity basketball team is shown in this image from 1909. The first intercollegiate game played by Tech was a home game on January 22, 1909, at which they defeated Emory and Henry College, 33-26. (DLA/University Libraries, VPI&SU.)

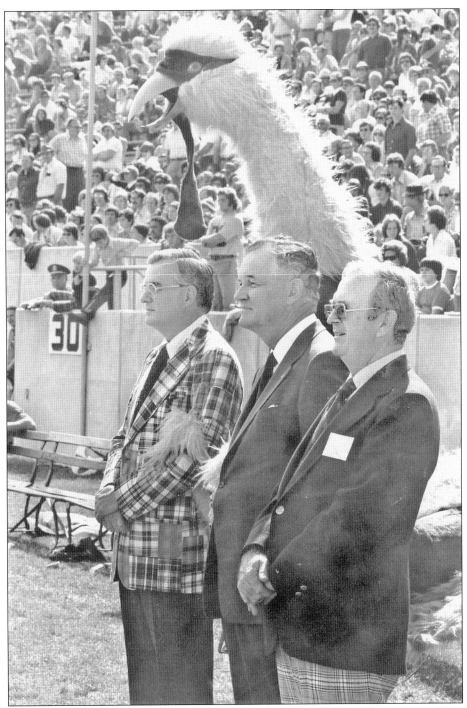

No visual history of Tech sports would be complete without the Hokie bird! The bird has gone through several transformations over the years. This look for the Hokie bird is from 1974. The bird towers over Tech president Marshall Hahn at left and Virginia governor Mills E. Godwin Jr. at center in Lane Stadium on Governor's Day. (DLA/University Libraries, VPI&SU.)

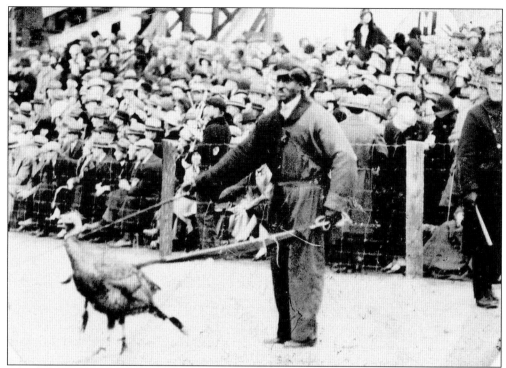

One of the earliest images of the Hokie bird as a mascot is this one taken in the fall of 1921. Floyd Meade, an employee of the college at the time, holds the gobbler. (DLA/University Libraries, VPI&SU.)

Times have changed for Tech sports since this photo of Tech baseball players warming up for a game was taken in the 1920s. These players may have actually benefited from one of the most significant steps Tech took in that era to promote its athletic program—the awarding of full scholarships to prospective athletes commenced in 1925. (DLA/University Libraries, VPI&SU.)

Four

THE CAMPUS

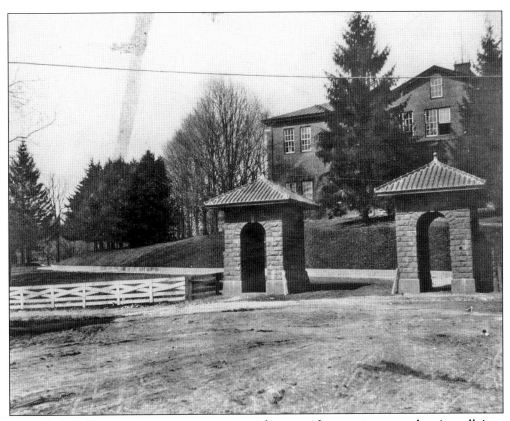

Around 1913, Alumni Gateway was constructed to provide an entrance and main walk into the campus. This 1914 photograph shows the gateway and shops. The gate was removed in1936 for the widening of Main Street. (DLA/University Libraries, VPI&SU.)

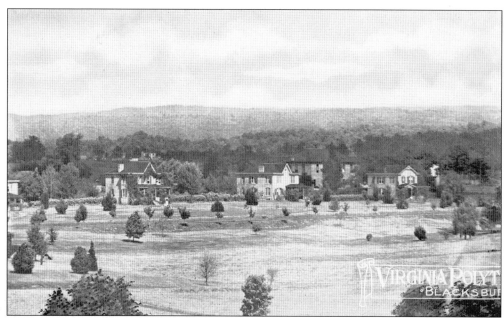

This and the image below are part of a collection of panoramic photographs of the Tech campus taken by Prof. James McBryde around 1907. This image shows the campus along Faculty Row. Faculty Row developed from a boulevard that was constructed in 1894, as early Tech leaders felt suitable housing for faculty in Blacksburg was almost impossible to find. (DLA/University Libraries, VPI&SU.)

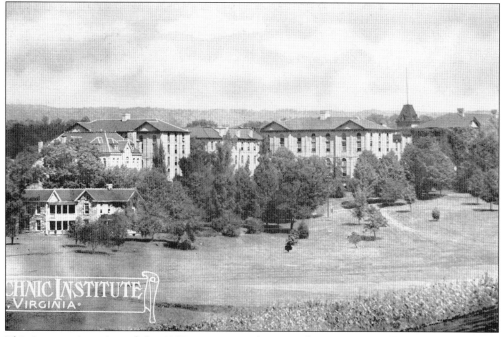

This is a continuation of the 1907 panorama showing the campus itself with barracks and academic buildings. Most of the buildings seen here were built between 1890 and 1900. (DLA/University Libraries, VPI&SU.)

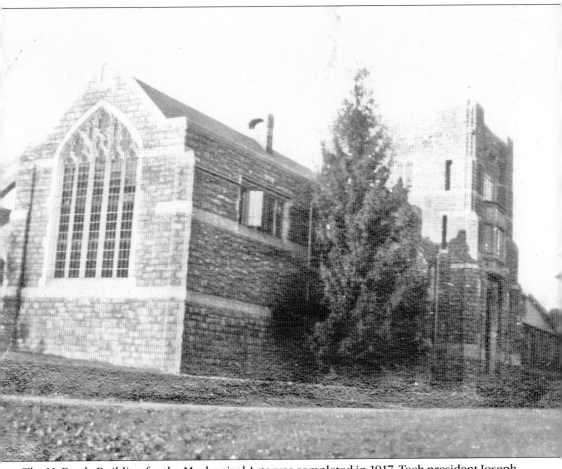

The McBryde Building for the Mechanical Arts was completed in 1917. Tech president Joseph D. Eggleston Jr. had suggested the new building be named after one of his predecessors, John M. McBryde, who served as Tech's president from 1891 to 1907. McBryde had overseen a number of physical, academic, and athletic improvements to the college during his term. One Tech historian noted that the construction of this building influenced the style of architecture followed on the campus for the next 50 years. J. Ambler Johnston wrote that the building's design, promoted by Eggleston, lifted VPI out of "the appearance of a trade school cow college." While some in the Virginia legislature criticized Eggleston in building for ornament and not for use, the McBryde building truly set the pace for Tech's neo-Gothic architectural style and construction consisting of native stone. The building was razed in 1966 and replaced by the present McBryde Hall. (DLA/University Libraries, VPI&SU.)

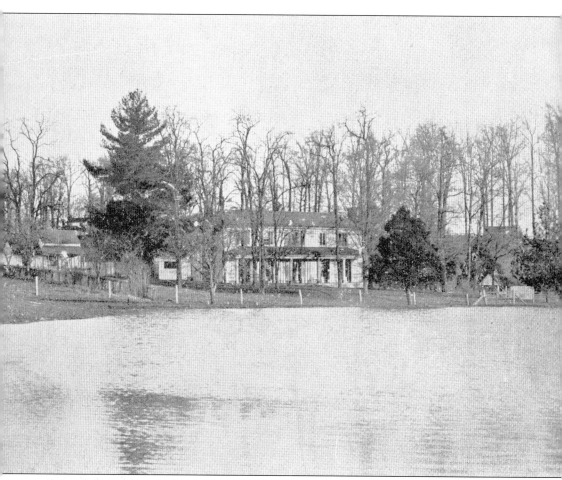

One of the oldest and most historic structures still on the Tech campus is Solitude. This home was located on a tract of land of approximately 250 acres that was purchased along with the Preston and Olin Institute of Blacksburg in cooperation with the Virginia State Agricultural Society. The purchase was made to create a college farm in preparation for the launch of what would ultimately become Virginia Tech. The Solitude farm was part of the Smithfield plantation belonging to Robert T. Preston. To the credit of the university, Solitude was renovated several times but never seriously considered for demolition. It served as headquarters for the Hokie Club and has been the object of archeological study in recent years. The above image was taken in April 1904 and published in the *Gray Jacket,* Tech's first school magazine, established by the students in 1873. (DLA/ University Libraries, VPI&SU.)

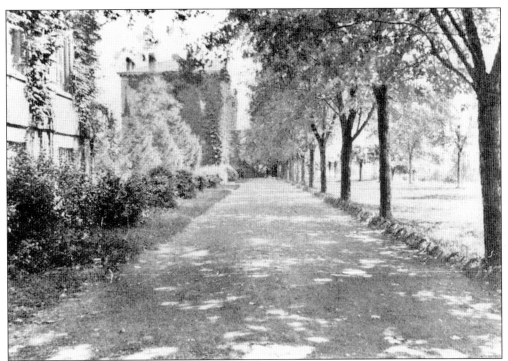

"The Long Walk" or "Lover's Lane" was the walkway that connected Barracks Number One with the Mess Hall. Early cadets became very familiar with this well-traveled passage. Eventually, the main walk was laid in concrete. This photo is dated around 1900. (DLA/University Libraries, VPI&SU.)

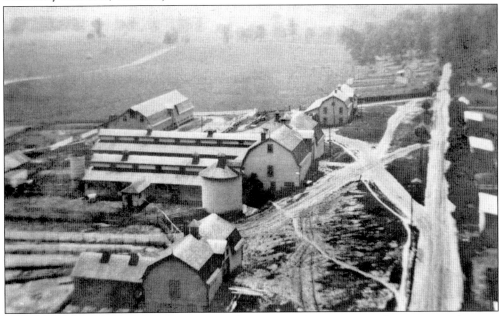

The agricultural barns. seen above in 1916, occupied the current parking area to the west of the coliseum. The barns served as a working lab for those studying agriculture. (DLA/University Libraries, VPI&SU.)

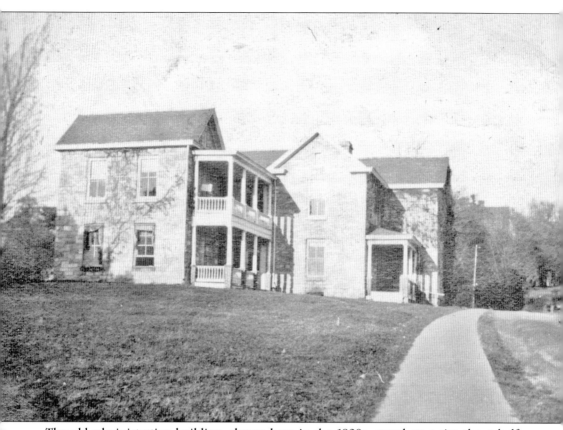

The old administration building, shown here in the 1920s, stood on a site about halfway between Patton Hall and Memorial Chapel. The administration offices were moved from here to Burruss Hall in July 1936. The old administration building was demolished in the summer of 1950 due to the construction of the World War II Memorial. The stones from the building were used in the construction of the memorial, as the building had been a fixture on the campus for nearly 50 years. (DLA/University Libraries, VPI&SU.)

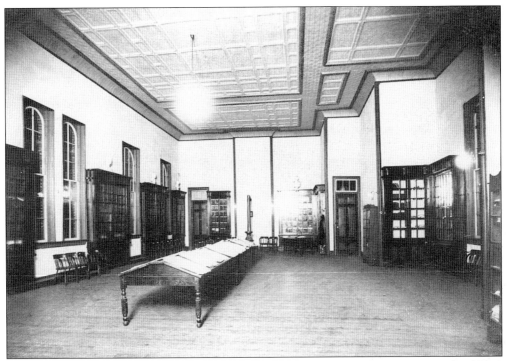

The college library of 1900 was on the second floor of the Second Academic Building. School dances, sponsored by the German Club, were often held in this room with the furnishings pushed to the side. (DLA/University Libraries, VPI&SU.)

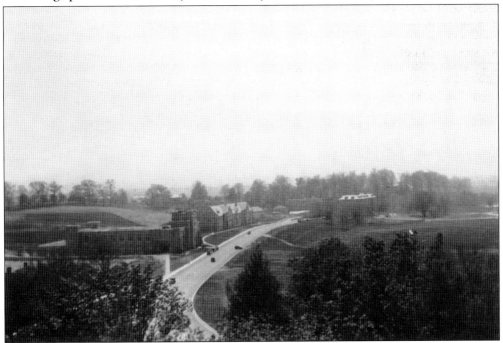

This photograph was taken from the roof of the old library, looking west across the drill field. The image is dated 1932. (DLA/University Libraries, VPI&SU.)

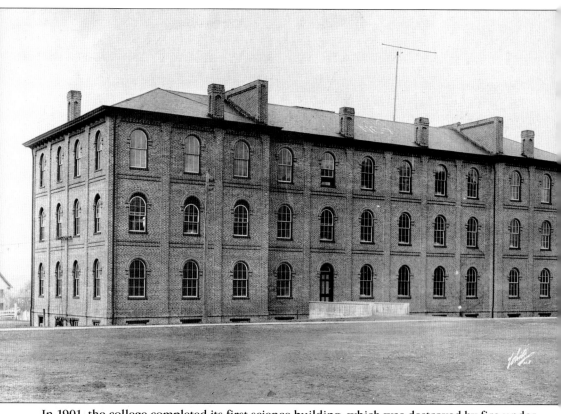

In 1901, the college completed its first science building, which was destroyed by fire under suspicious circumstances four years later. On the same site, the college erected a second science hall, shown here in 1918. The building was used for academic purposes until 1927, when it was converted into a dormitory, Barracks Number Seven. The structure was razed in 1957 to make room for the addition to Shanks Hall. (DLA/University Libraries, VPI&SU.)

Before concrete sidewalks, the campus was connected by a number of boardwalks, as is evidenced by this image from the 1933 *Bugle*. The buildings shown are dormitories. (DLA/University Libraries, VPI&SU.)

This image shows some the beginning of the conversion from boardwalks to concrete, as a laborer appears to be working with concrete in the lower left corner of this 1933 photograph. (DLA/University Libraries, VPI&SU.)

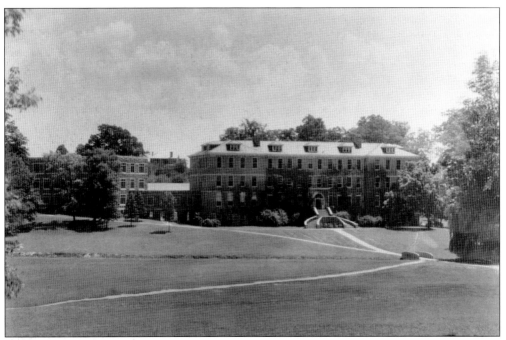

This is a view looking across campus at one of the academic buildings in 1933. (DLA/University Libraries, VPI&SU.)

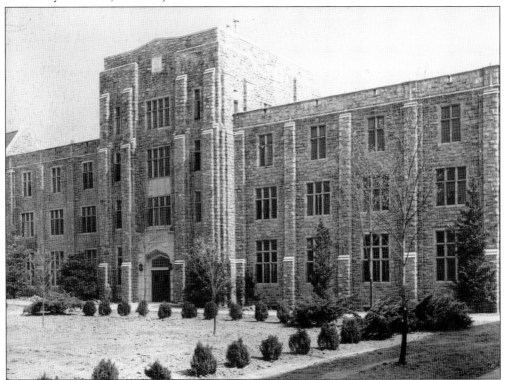

This 1951 image shows Seitz Hall, formerly the Agricultural Engineering Building. Completed in 1937, it was named for Prof. C.E. Seitz in 1956. (DLA/University Libraries, VPI&SU.)

There were a number of things that impacted the Tech campus over the years—fires, renovations, demolitions, and expansions. In 1943 Mother Nature took a turn as heavy rains flooded portions of the campus. (DLA/University Libraries, VPI&SU.)

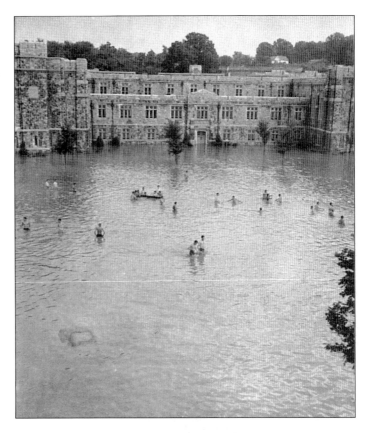

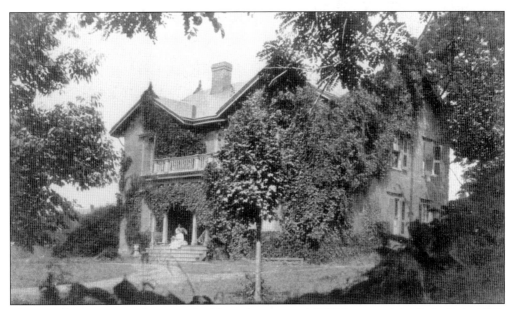

The President's Home, photographed here in autumn of 1899, was originally built in 1876. Many may recognize it today as the original section of Henderson Hall. It is the second-oldest structure on the campus. (DLA/University Libraries, VPI&SU.)

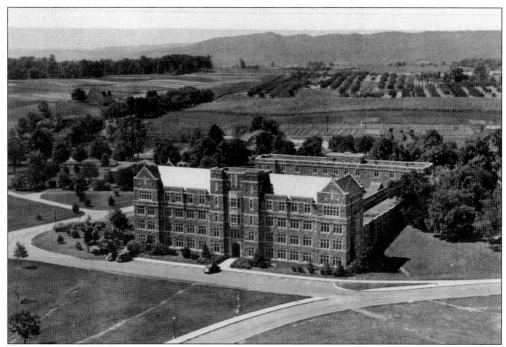

Davidson Hall, shown in 1932, was named for Prof. R.J. Davidson. The front section was completed in 1927, and additional sections were completed in 1933 and 1938. (DLA/University Libraries, VPI&SU.)

Patton Hall was named for Prof. William Patton. The first section of this hall was completed in 1926 and the last section in 1929. The construction of Davidson and Patton was made possible by state appropriations in 1926 for additional dormitories. (DLA/University Libraries, VPI&SU.)

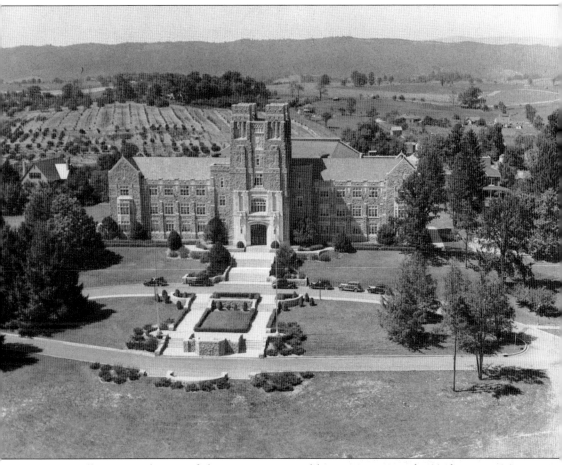

Burruss Hall is certainly one of the most recognizable structures on the Tech campus. It originally went by the nickname "T and A Building," in reference to it being the Teaching and Administration Building. Opened in June 1936, its name was changed to Burruss Hall in 1944 in honor of Pres. Julian A. Burruss, who served from 1930 until 1945. Dr. Burruss had served Tech in a number of capacities in addition to being president. In January 1945, Dr. Burruss was in automobile accident while returning from Roanoke, Virginia. The accident hampered his public appearances and college activities. One of the most visionary presidents to serve Tech, Dr. Burruss died on January 4, 1947. The above photograph was taken in 1939. (DLA/University Libraries, VPI&SU.)

This was the Tech campus in 1929. In the background at left is the War Memorial Gymnasium, and in the center background is Agriculture Hall. In the foreground left are the rooftops of Barracks Five and Six and the YMCA. In the bottom center is McBryde Hall. (DLA/University Libraries, VPI&SU.)

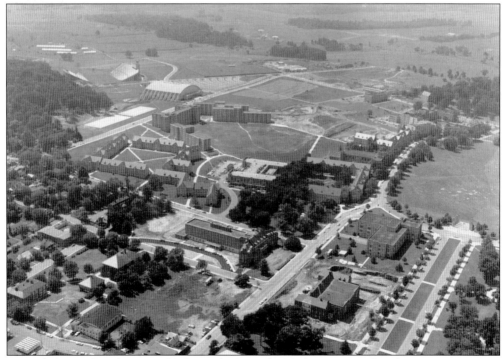

In contrast to the photograph above, here is the Tech campus of 1967. (DLA/University Libraries, VPI&SU.)

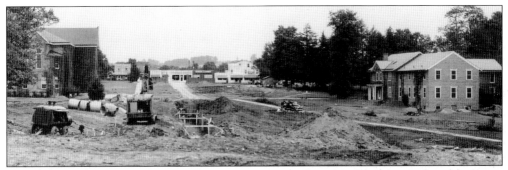

In the early 1950s a grove of trees was removed for the development of the mall. During its development a number of students and faculty complained about the mud and destruction of trees. When Tech chancellor John R. Hutcheson was asked if the mall would ever be beautiful, he responded, "People are blaming me for putting the forces into operation which led to this mall. I am perfectly willing to accept the blame for the mall now if people will give me the credit for it when they view it 25 years from now." (DLA/University Libraries, VPI&SU.)

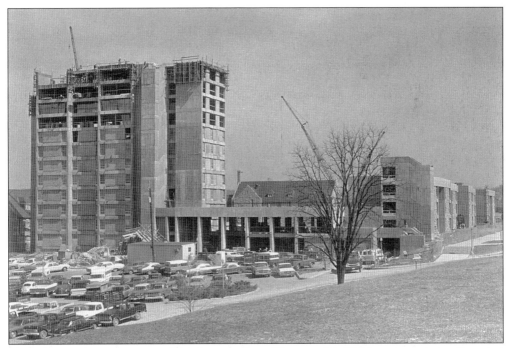

Under the administration of Tech president Thomas M. Hahn, a number of capital improvements were made to the campus in the 1960s. Among them was the construction of Slusher Hall, a women's dorm named for Mrs. Clarice Slusher Pritchard, Registrar Emeritus. (DLA/University Libraries, VPI&SU.)

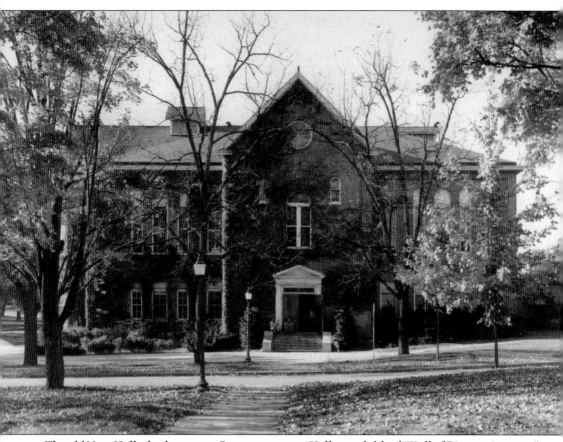

The old Mess Hall, also known as Commencement Hall, was dubbed "Hall of Disappointment" by cadets due to the fare served. The building was completed before the turn of the last century and stood on the Tech campus until 1955 when it was razed, being beyond restoration. This building had gone through a number of incarnations. In addition to being known as the Mess Hall and Commencement Hall, it was also known for a time as "German Hall" due to its use by the German Club for a number of their functions. In its final use, the structure had been converted to classrooms and was known as "Commerce Hall." It stood on a site adjacent to the Shultz Dining Hall. This image was taken in 1949. (DLA/University Libraries, VPI&SU.)

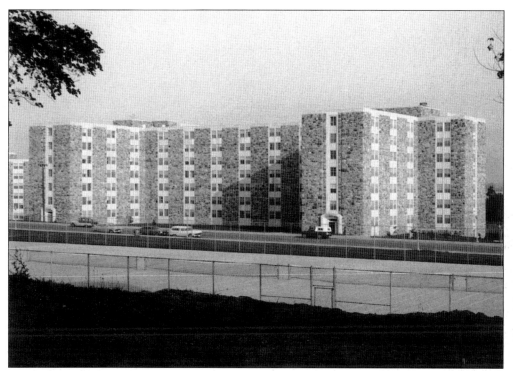

During the 1964–1965 session, Lee, Johnson, and Pritchard Halls were constructed. Lee Dormitory, shown here, was named for electrical engineering professor Claudius Lee. This photo was taken in 1968. (DLA/University Libraries, VPI&SU.)

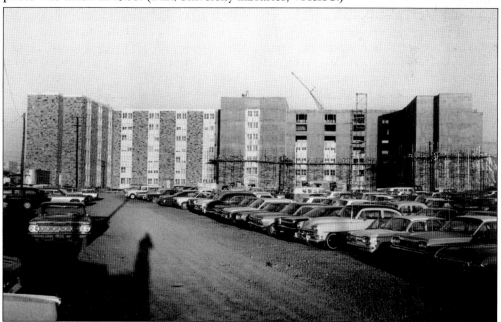

Ambler Johnston Hall, shown here in 1968, was named for one of Tech's most active alumni. Johnston, founder of a well-known architectural firm, advised six Tech presidents. (DLA/University Libraries, VPI&SU.)

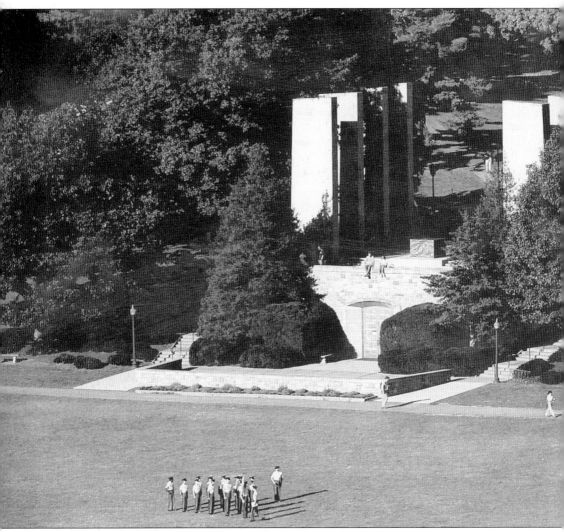

In 1946, Tech alumni were presented with plans to erect a World War II memorial. Within four years, the Alumni Association had raised sufficient funds to start the construction. D.P. Morton, class of 1911, chaired the memorial committee. The memorial was intended to honor Tech alumni who gave their lives in service to their country. A service of dedication was held on May 29, 1960. Beneath the Memorial Court is a 350-seat chapel. The court consists of eight pylons representing brotherhood, honor, leadership, sacrifice, service, loyalty, duty, and the university's motto "That I May Serve." (DLA/University Libraries, VPI&SU.)

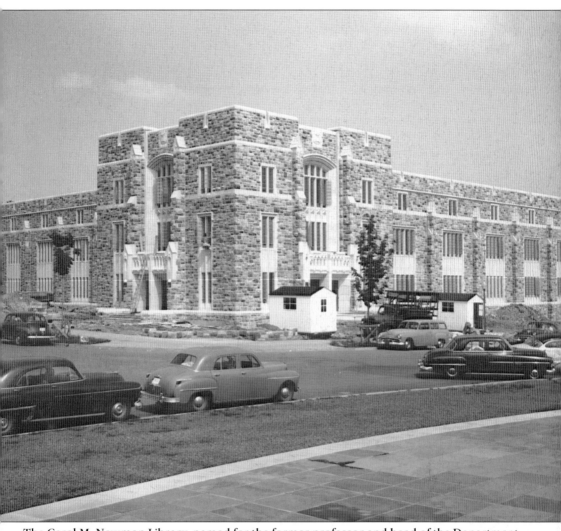

The Carol M. Newman Library, named for the former professor and head of the Department of English, was completed in 1955. Philanthropist Paul Mellon contributed $1 million for the project. The old library building was demolished, and temporary library facilities were established in the old Academic Buildings One and Two while Newman was being constructed. The Newman Library was part of a significant capital improvement program during the 1950s under the administration of Pres. Walter Newman, who served from 1947 until 1962. The above image was taken about 1960. (DLA/University Libraries, VPI&SU.)

Eggleston Hall, originally known as East Stone Dormitory Number One, was completed in 1935. Wings were added four years later, and the dorm was renamed Eggleston in 1952. Eggleston underwent subsequent renovations. This image from 1990 shows East Eggleston. (DLA/University Libraries, VPI&SU.)

In 1950, the Board of Visitors decided to improve the campus to accommodate an enrollment of 10,000 students. Part of the implementation of that decision was the construction of Williams Hall, completed in 1952. Student protesters occupied Williams Hall in the spring of 1970 following the shootings at Kent State University. State police were summoned to assist in arresting and evacuating the students. (DLA/University Libraries, VPI&SU.)

The Squires Student Center was originally known as SAB, or Student Activities Building. The initial portion of the building was constructed in 1937 and was renamed Squires Hall in 1949. With a significant expansion and remodeling program in 1969, the structure was renamed the Squires Student Center. The building was named for John H. Squires of the class of 1905. In addition to his substantive financial contribution for the center, Squires had an interesting history with Tech. Having been suspended along with several other classmates from a North Carolina institution for insubordination, Squires wrote the president of Tech, Dr. McBryde at that time, asking for admission. McBryde, having made some calls to check on Squires, agreed to receive him as a student. That admission launched a relationship between Squires and Tech that lasted for many years. (DLA/ University Libraries, VPI&SU.)

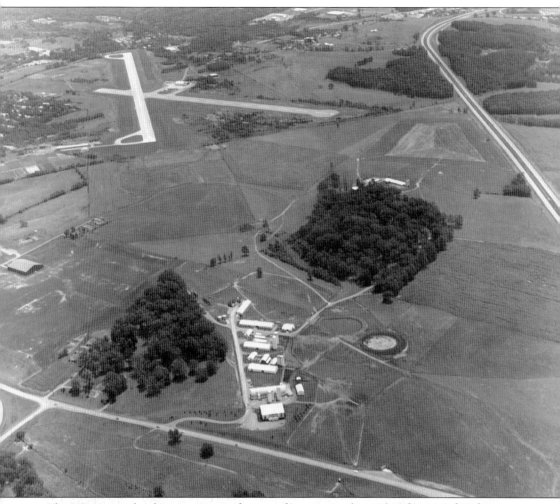

The VPI Airport has been existence for over 60 years. In the mid-1960s its 2,600-foot runway was expanded to 4,600 feet. This expansion required the Norfolk and Western Railway to remove the tracks of the *Huckleberry*, thereby ending the train's run permanently. (DLA/ University Libraries, VPI&SU.)

Five

STUDENT LIFE

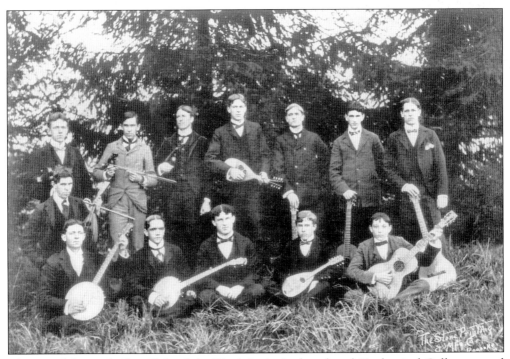

The Mandolin and Glee Club of the Virginia Agricultural and Mechanical College posed for this image in 1894.

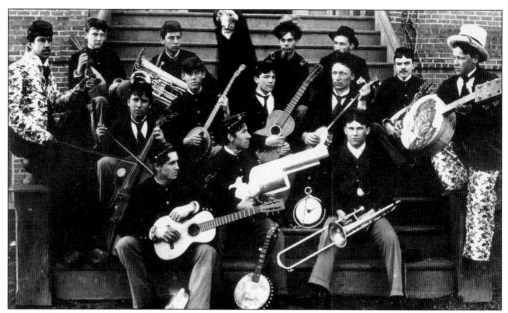

Virginia Agricultural and Mechanical College also had a thespian club in 1894–1895. Members pictured include Julian Johns, Franklin Turner, Samuel Fraser, Herbert Gormely, Allen Morrissett, Robert Wainwright, Henry Hurst, and John Walk. Some theatrical props—an oversized pistol and pocketwatch—are visible in the front row. (DLA/University Libraries, VPI&SU.)

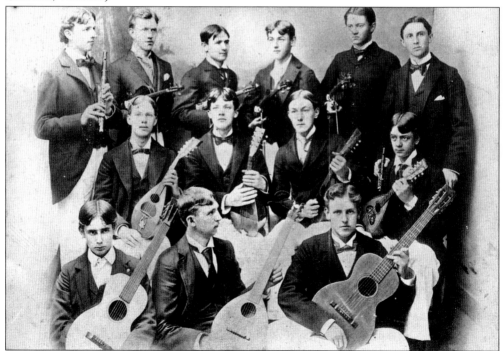

Here is a campus orchestral group from 1896. According to information accompanying the photo, this group performed the music for dances held on the second floor of the library in the 1890s. (DLA/University Libraries, VPI&SU.)

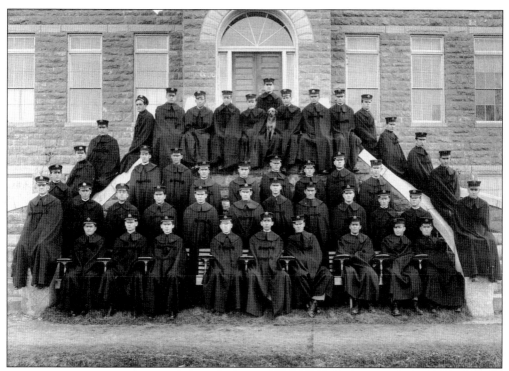

Compared to the sizes of today's graduating classes, the class of 1913 seems a bit small. Even the canine mascot made the picture (top center). (DLA/University Libraries, VPI&SU.)

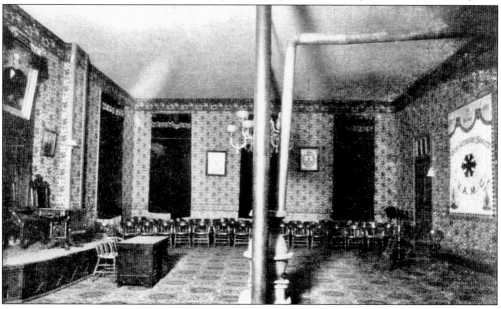

The hall of the Maury Literary Society was on the second floor of the Second Academic Building when this 1900 image was taken. Early in its history, VPI had two main literary societies—Lee and Maury. The societies engaged cadets in oratory, debate, writing, and reading. Students took membership and award achievements in the societies quite seriously. (DLA/University Libraries, VPI&SU.)

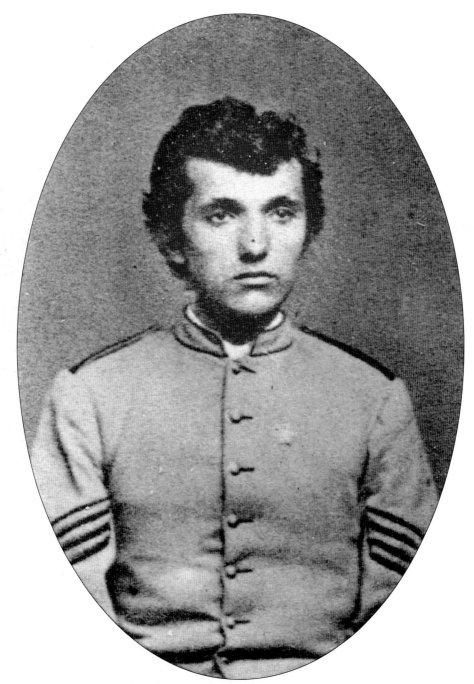

No chapter on student life would be complete without some recognition of the first student. William A. Caldwell of Craig County, Virginia, was the first student to enroll at the Virginia Agricultural and Mechanical College after it officially opened on October 1, 1872. Some suggest Caldwell merely visited the college out of curiosity with no real intention of enrolling. Nonetheless, he was awarded a scholarship by faculty, enrolled, and made a mark in the annals of Tech history. By the end of the first academic year, there was a total enrollment of 132 students, all from Virginia. (DLA/University Libraries, VPI&SU.)

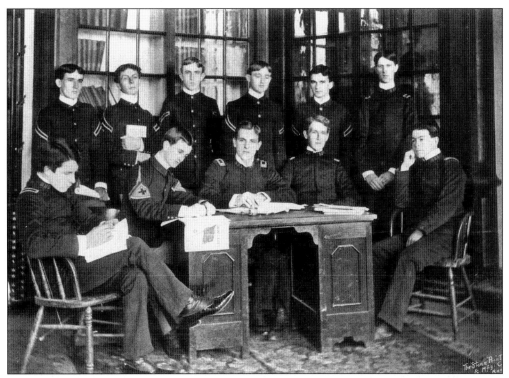

This is the staff of the *Gray Jacket* from 1900. (DLA/University Libraries, VPI&SU.)

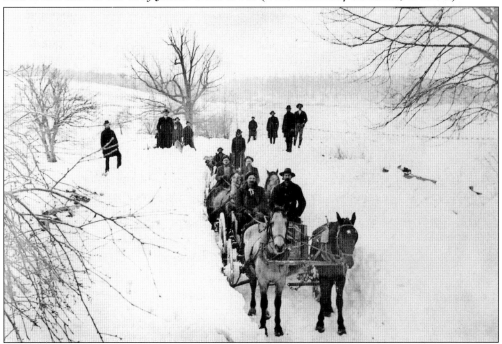

A record snowfall occurred in the winter of 1895. In this photograph, Prof. William Alwood, at far left, and some students are making the best of what Mother Nature delivered. (DLA/University Libraries, VPI&SU.)

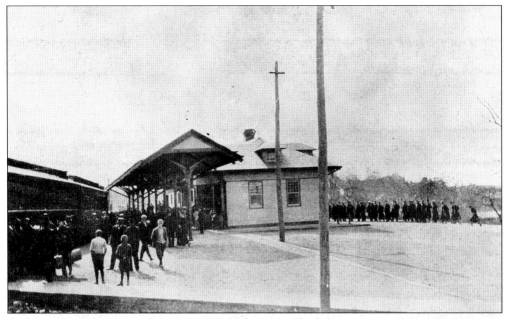

Cadets and others wait to board the *Huckleberry* in Blacksburg to go to Roanoke, Virginia, for the annual VPI-VMI football game on Thanksgiving Day in 1913. (DLA/University Libraries, VPI&SU.)

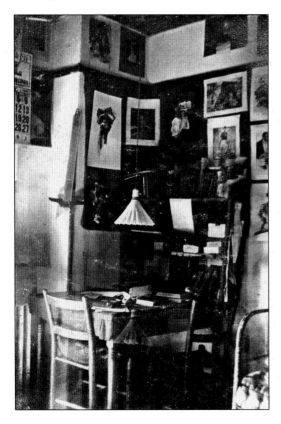

Here is a *c.* 1890s dorm room with plenty of wall art. (DLA/University Libraries, VPI&SU.)

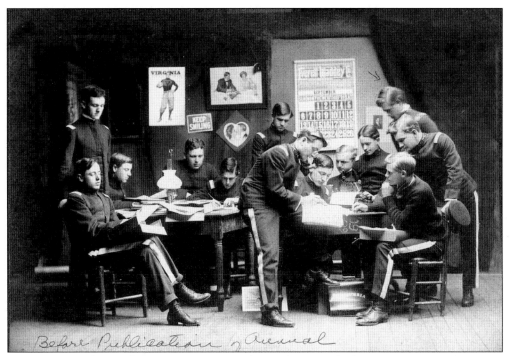

The staff of *The Bugle* is hard at work when photographed in 1908. (DLA/University Libraries, VPI&SU.)

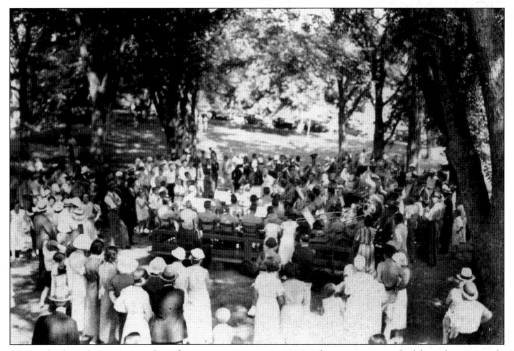

The cadet band gives a Sunday afternoon concert in 1933. The concert was held on the grounds between the quadrangle and College Avenue. (DLA/University Libraries, VPI&SU.)

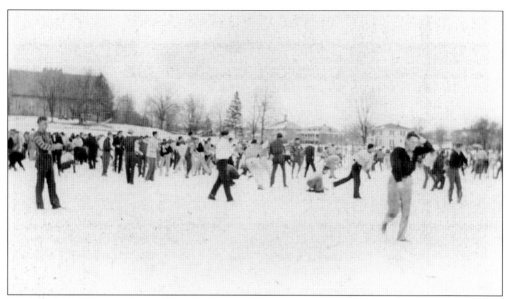

This 1932–1933 photograph had the following inscribed on the back: "First suitable snow in three years; therefore, three classes (34, 35, and 36) were in it. It was a big one." (DLA/University Libraries, VPI&SU.)

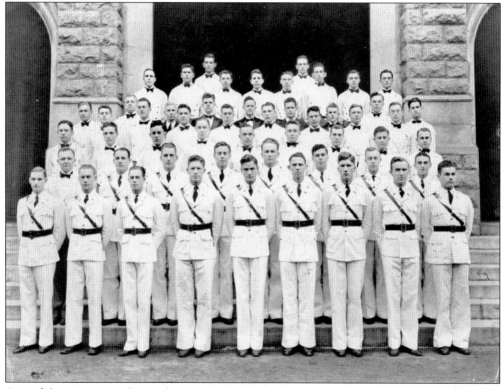

One of the more popular student organizations over the years has been the German Club. This club dates back to the late 1800s. This image shows the members from the spring semester of 1934. (DLA/University Libraries, VPI&SU.)

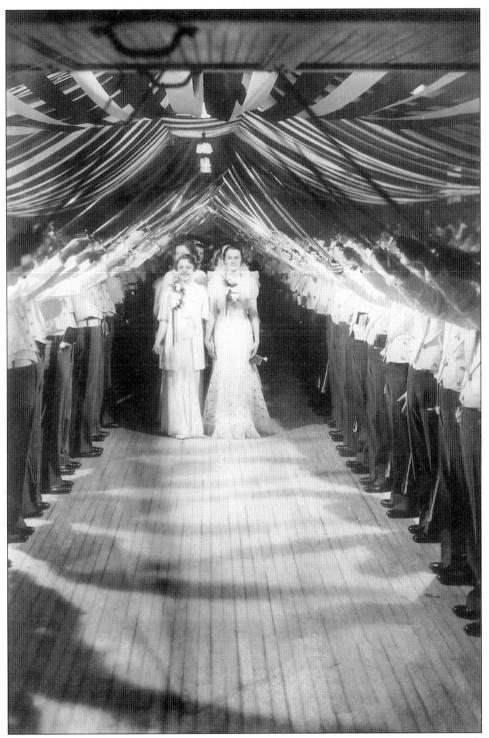

This image from the 1935 *Bugle* shows a scene from the first junior class Ring Dance that was held on April 27, 1934. The dance has been held every year since that time. (DLA/University Libraries, VPI&SU.)

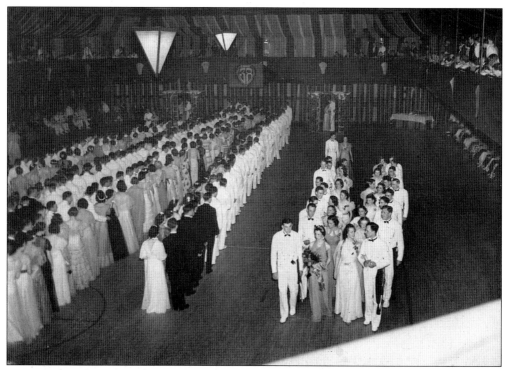

This photograph from 1934 shows a promenade at a military ball that year. (DLA/University Libraries, VPI&SU.)

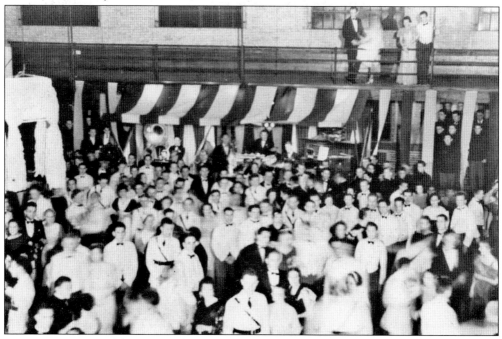

This image shows the 1934 Junior-Senior Prom in War Memorial Gymnasium. According to information accompanying the photo, Mal Hallett and his orchestra played for the dance. (DLA/University Libraries, VPI&SU.)

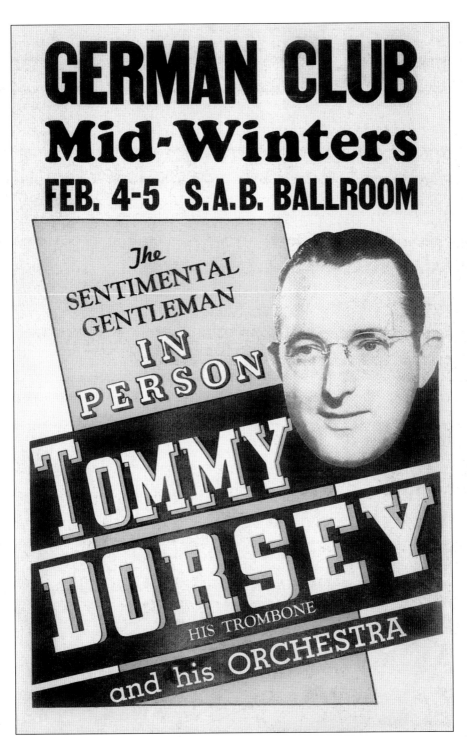

Tech's German Club is known for the dances they have sponsored over many years. This poster from the 1940s promotes one such dance with the notable Tommy Dorsey and his orchestra. The German Club often brought in nationally known bands and orchestras for the dances. (DLA/University Libraries, VPI&SU.)

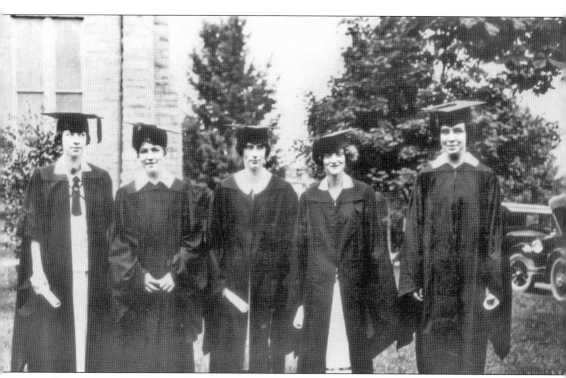

Shown above are the very first co-eds to graduate from Tech in 1925. They are, from left to right, Mary Ella Carr Brumfield, Ruth Terrett, Lucy Lee Lancaster, Louise Jacobs, and Carrie Taylor Sibold. President Burruss promoted the notion of admitting women to Tech in 1920. Though a previous president had mentioned the idea back in 1908 and President Eggleston had allowed women to enroll in summer courses, Burruss championed the idea of co-education. Given the infusion of women into the workplace during World War I and the gains made by the women's suffrage movement, the Tech Board of Visitors voted unanimously to admit women to all courses except military ones beginning in September 1921. The cadets were not as enthusiastic as the board when the co-eds arrived. Some protested, others injected humor into the situation, but eventually the five co-eds and seven part-time co-eds who enrolled in 1921 were accepted by their male colleagues. The editor of *The Virginia Tech* wrote tongue-in-cheek, "The making of VPI a co-ed school failed to bring many members of the fairer sex within her walls, but it produced remarkable results in other ways. VPI has the largest enrollment of cadets in the history of the school." (DLA/University Libraries, VPI&SU.)

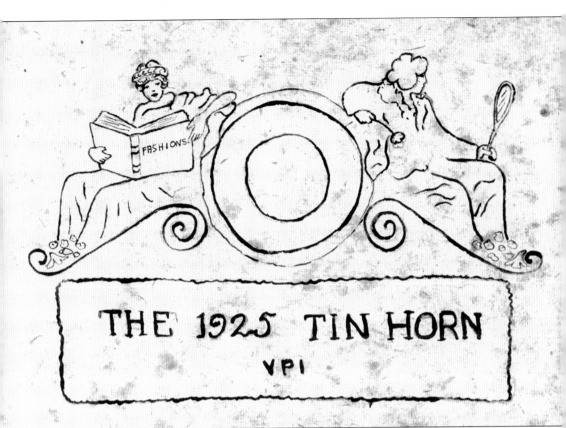

This cover page of the 1925 *Tin Horn* illustrates the barrier to acceptance experienced early on by women at Tech. Denied admission to certain clubs, coeds were also not allowed to participate in student publications. The women eventually formed their own basketball team, the Turkey Hens, and issued their own yearbook, *The Tin Horn*, having been excluded from *The Bugle*. In 1936, *The Bugle* opened their pages to women. (DLA/ University Libraries, VPI&SU.)

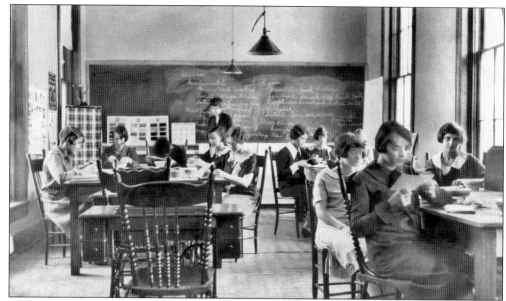

This image from the 1930s shows female students in the textile lab. This decade marked significant advances for women at Tech. The Women's Student Organization started in 1930, and in 1934 the Women's Student Union was organized. (DLA/University Libraries, VPI&SU.)

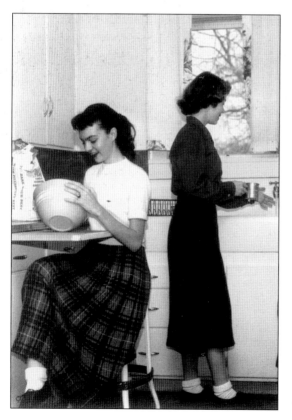

Students are shown working in the home economics kitchen in the 1950s. Home economics was added to the Tech curriculum during the tenure of President Burruss. (DLA/University Libraries, VPI&SU.)

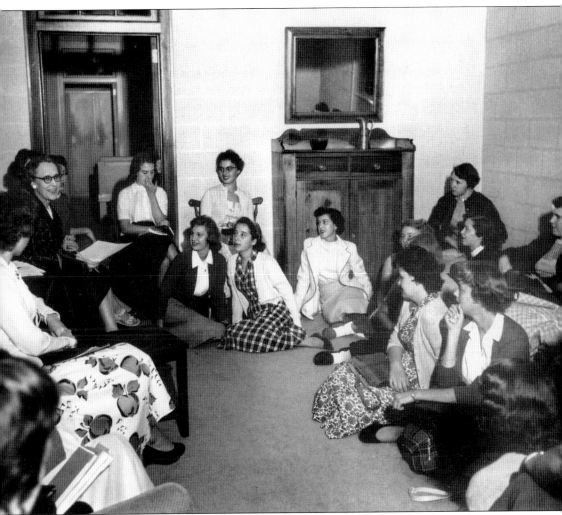

Dr. Mildred T. Tate assisted with the growth of coeducation perhaps more than any other single individual. Dr. Tate served as head of the home economics department and dean of women for many years; she conducted numerous drives and promotions to bring Tech to the attention of Virginia's women. This photo shows Dr. Tate talking with new female students on their first day at Tech in 1955. Having joined the Tech faculty in 1937, Dr. Tate retired on July 1, 1958, and was succeeded by Dr. Laura Jane Harper.

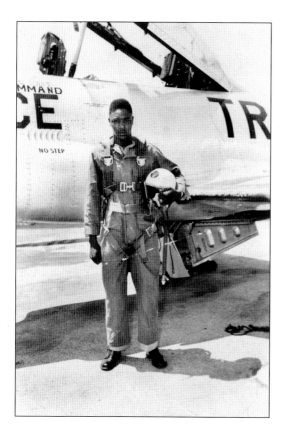

Charlie Yates, shown here in 1958, was the first African American to graduate from Virginia Tech. In 1957, he received a B.S. degree in mechanical engineering. He would later join the faculty at Tech. (DLA/University Libraries, VPI&SU.)

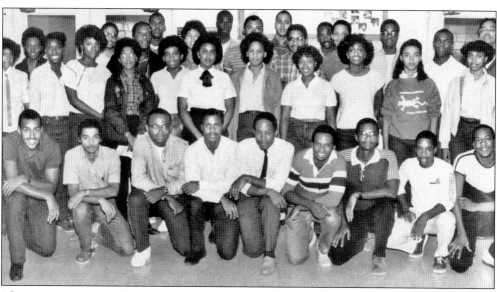

African-American students have made much progress since the integration of Tech in 1953. Here is the chapter of the National Society of Black Engineers from 1985. (DLA/University Libraries, VPI&SU.)

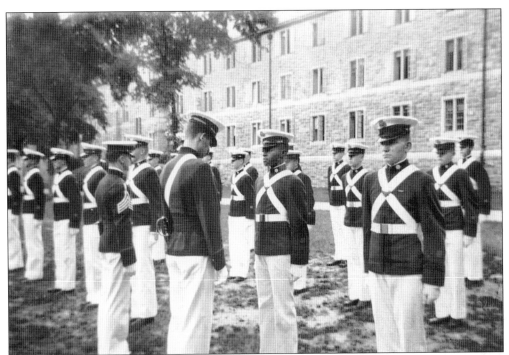

Cadet Lindsay Cherry with Company A is shown in this image from the mid-1950s. Cadet Cherry was one of the first African-American students at Tech. The first black female cadet was Cheryl Butler in 1973. (DLA/University Libraries, VPI&SU.)

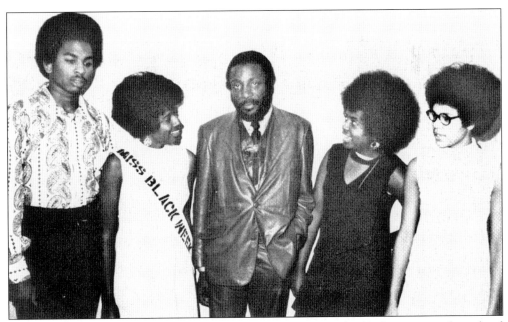

With the growing diversity of the student population on the Tech campus, the school developed a human relations council. In this 1971 photo, officers of the council are shown with Dick Gregory (center). (DLA/University Libraries, VPI&SU.)

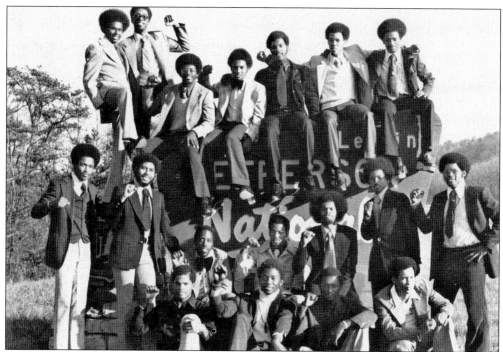

African-American students have made significant gains and influenced tremendously the Tech community since admission a half-century ago. The first African-American women arrived on campus in 1966, and the first African-American faculty member was hired in 1969. Above is the Alpha Phi Alpha Fraternity on an outing to the Jefferson National Forest in 1976. (DLA/University Libraries, VPI&SU.)

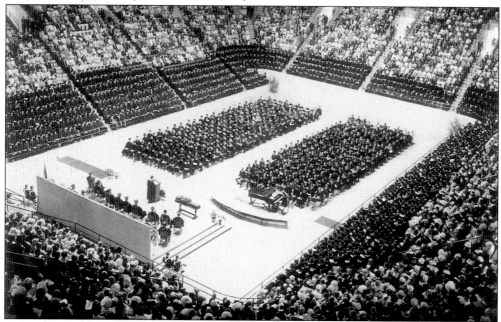

Pictured above is the Virginia Tech graduation ceremony of 1964, held in Cassell Coliseum. (DLA/University Libraries, VPI&SU.)

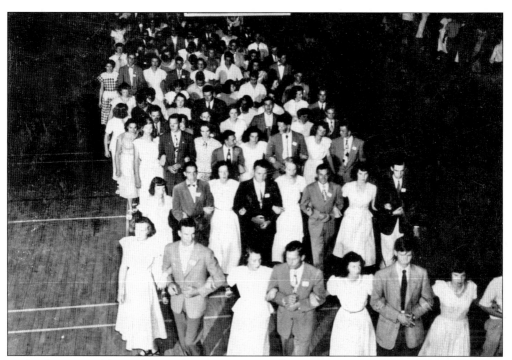

Tech often stayed busy during the summer with 4-H activities. Here is the "Grand March" in Memorial Gym for the 4-H party in 1949. (DLA/University Libraries, VPI&SU.)

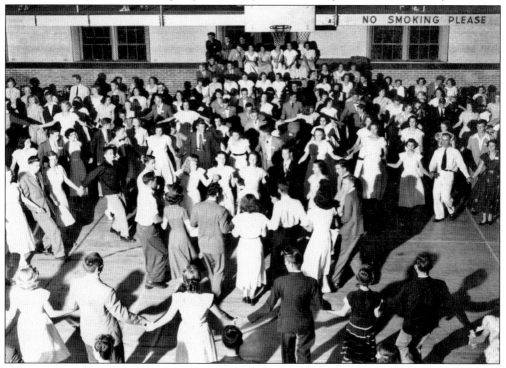

Tech students and others enjoy the 4-H square dance held in Memorial Gym in 1949. (DLA/ University Libraries, VPI&SU.)

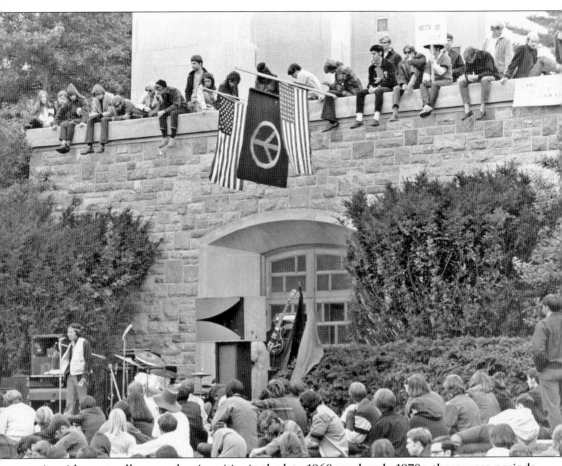

As with most colleges and universities in the late 1960s and early 1970s, there were periods of student unrest. This 1970 image shows a student demonstration against the war in Vietnam. Demonstrations were not limited to American foreign policy; in the spring of 1970, some students and faculty purposefully disrupted the Corps of Cadets during a routine drill. Following the events of Kent State University, the campus received bomb threats and students occupied Cowgill Hall and Williams Hall for brief periods. Many of the students who occupied Williams were suspended for two quarters. The following session, 1971–1972, students boycotted the bookstore in order to gain a voice in the distribution of bookstore profits, and there was the "open door" protest against a university policy requiring a dorm door be open six inches if a member of the opposite sex was visiting. Tech historian Duncan Kinnear, noting the protests and sit-ins, made the following observation about that period: "To some faculty members, these new modes of expression were as bewildering and baffling as were the students' beards, long hair, bare feet, and sloppy dress which suddenly became the common classroom badge for many students."

Six

BLACKSBURG

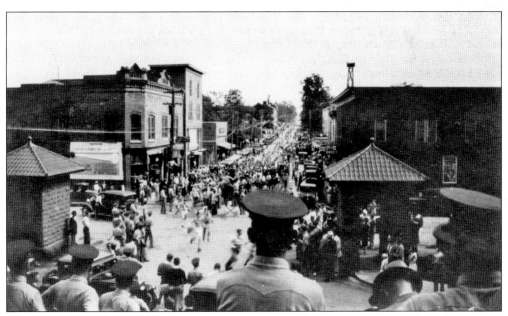

The town of Blacksburg has been an integral part of the Tech story. In this photograph from 1933, the cadet rat parade moves through downtown Blacksburg. (DLA/University Libraries, VPI&SYU.)

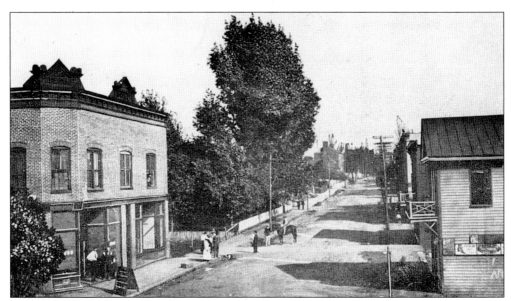

The above image of Blacksburg shows the downtown area in the 1880s. Dirt streets, boardwalks, and a few commercial buildings greeted the incoming students to the Virginia Agricultural and Mechanical College during that era. (DLA/University Libraries, VPI&SU.)

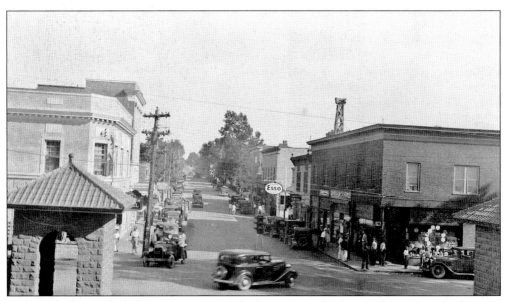

Forty years later, Blacksburg's Main Street had progressed. The small tower in the bottom left is part of Alumni Gateway, which marked the entrance to the Tech campus during the 1920s. The date of this photo is 1925. (DLA/University Libraries, VPI&SU.)

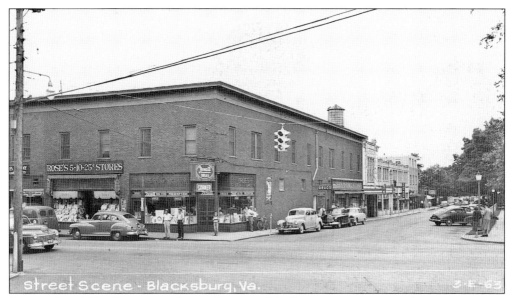

During the 1940s the corner of Main Street and College Avenue contained Roses 5–10–25¢ Store, the Corner Drugstore, and the Lyric Theater. (DLA/University Libraries, VPI&SU.)

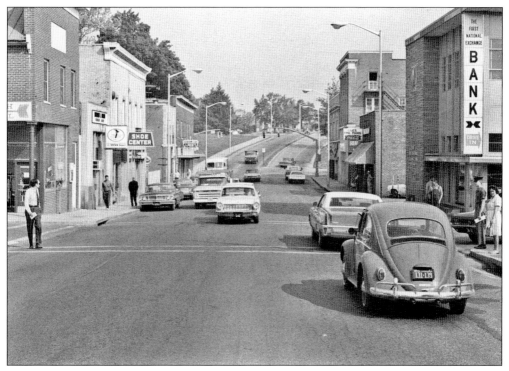

Here is a more familiar-looking Blacksburg though still back in time—1970. (DLA/University Libraries, VPI&SU.)

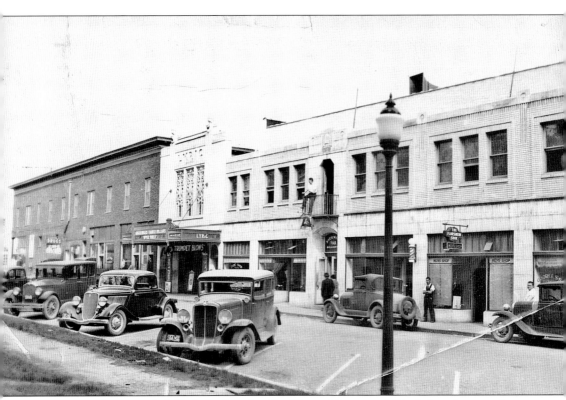

Anyone who attended Tech had to be familiar with one of Blacksburg's most known attractions, the Lyric Theater. Now a non-profit theater, the Lyric has been a part of Blacksburg for over a century. The above streetscape, which includes the Lyric, was taken in 1934. (DLA/University Libraries, VPI&SU.)

NOTES AND ANECDOTES

ORIGINAL COLLEGE YELL
Virginia Agricultural and Mechanical College
(Adopted during the 1891–1892 Session)

Rip Rah Ree!
Va., Va., Vee!
Virginia, Virginia!
AMC.

HOKIE CHEER
(By O.M. Stull, Class of 1896)

Hokie, Hokie, Hokie, Hi!
Tech, Tech, VPI
Sol-a-rex, Sol-a-rah
Poly-tech Vir-gin-ia
Ray rah VPI
Team! Team! Team!

VPI VICTORY MARCH
(Original)

You've seen the Hoyas tumble,
You've made the Indians cry;
And you know the Army mule
Once took a kick at VPI.
Worthy teams from Lexington
Have fought with all their might;
And now it's time to show the world
That victory is ours tonight!

Go, Tech!
Go, Tech!
H-O-K-I-E-S, Hokies!

VPI VICTORY MARCH
(Revised 2000)

You've seen Mountaineers fumble,
You've been in Hurricane's eye,
And you know 'ol Syracuse
Has learned the force of Hokie-Hi.
Worthy teams from all around,
Like Hoos from UVA,
Know a winning team awaits them;
Victory is ours today.

Go, Tech!
Go, Tech!
H-O-K-I-E-S, Hokies!

Tech Triumph

Techmen, we're Techmen, with spirit true and faithful,
Backing up our teams with hopes undying;
Techmen, Oh, Techmen, we're out to win today,
Showing pep and life with which we're trying;
VP, old VP, you know our hearts are with you
In our luck which never seems to die;
Win or lose, we'll greet you with a glad returning,
You're the pride of VPI.

(chorus)
Just watch our men so big and active
Support the orange and maroon. Let's go Techs.
We know our ends and backs are stronger,
With winning hopes, we fear defeat no longer.
To see our team plow through the line, boys.
Determined now to win or die;
So give a Hokie, Hokie, Hokie, Hi,
Rae, Ri, old VPI.

Fight, men, oh, fight men, we're going to be the champions
Adding to our list another victory;
Football or baseball, the games in which we star,
They're the sports which made old VP famous.
Hold 'em, just hold 'em, you know the Corps' behind you
Watching every movement that you make.
Winning games was nothing for our teams before you.
Keep the "rep" for VP's sake.

Virginia Tech Alma Mater

Sing praise to Alma Mater dear,
For V.P.I. we'll ever cheer;
Come lift your voices, swell the song,
Our loyalties to her belong.

Chorus:
So stand and sing, all hail to thee.
V.P., all hail to thee.

The Orange and Maroon you see,
That's fighting on to victory;
Our strife will not be long this day,
For glory lies within this fray.

All loyal sons and daughters, one,
We raise our banner to the sun;
Our motto brings a spirit true,
That we may ever serve you.

School Colors

Black and cadet gray were adopted as the school colors in 1891.
Chicago maroon and burnt orange were adopted as the school colors in the fall of 1896
and were first worn in a football game with Roanoke College on October 26, 1896.

School Motto

Ut Proism
"That I May Serve"
Adopted in 1896

School Names

Virginia Agricultural and Mechanical College (1872–1896)
Virginia Agricultural and Mechanical College and Polytechnic Institute (1896–1970)
Virginia Polytechnic Institute and State University (1970–present)

Presidents of Virginia Tech

Charles Landon Carter Minor (1872–1879)
John Lee Buchanan (1880)
Scott Shipp (1880)
John Hart (1880–1881)*
John Lee Buchanan (1881–1882)
Thomas Nelson Conrad (1882–1886)
Lindsay Lunsford Lomax (1886–1891)
John McLaren McBryde (1891–1907)
Paul Brandon Barringer (1907–1913)
Joseph Dupuy Eggleston, Jr. (1913–1919)
Julian Ashby Burruss (1919–1945)
John Redd Hutcheson (1945–1947)
Walter Stephenson Newman (1947–1962)
Thomas Marshall Hahn, Jr. (1962–1974)
William Edward Lavery (1975–1987)
Paul Ernest Torgersen (1988)*
James Douglas McComas (1988–1993)
Paul Ernest Torgersen (1994–2000)
Charles W. Steger (2000–present)

* acting/interim president

Virginia Tech All-American Athletes

YEAR	NAME	SPORT
1958	Carroll Dale	Football
1959	Carroll Dale	Football
1959	Brandon Glover	Wrestling
1962	Bucky Keller	Basketball
1962	Howard Pardue	Basketball
1963	Bob Schweickert	Football
1964	Bob Schweickert	Football
1965	Tim Collins	Golf
1966	George Foussekis	Football
1966	Frank Loria	Football
1967	Tim Collins	Golf
1967	Frank Loria	Football
1968	Mike Widger	Football
1972	Don Strock	Football
1976	Keith Neff	Track and Field
1978	Dennis Scott	Track and Field
1980	Ray Ackenbom	Track and Field
1980	Mike Burns	Track and Field
1980	John Dyer	Track and Field
1980	Lucy Hawk Banks	Track and Field
1980	Kenny Lewis	Track and Field
1980	Ray McDaniels	Track and Field
1980	Bruce Merritt	Track and Field
1980	Bob Phillips	Track and Field
1981	Robert Brown	Football
1981	Tracy Deely	Cross Country
1981	Lori McKee Taylor	Cross Country
1981	Franklin Stubbs	Baseball
1981	Paul Sulik	Track and Field
1981	Judy Williams	Track and Field
1982	Steve Hetherington	Cross Country
1982	Lori McKee Taylor	Track and Field
1982	Jim Stewart	Baseball
1982	Franklin Stubbs	Baseball
1983	Bruce Smith	Football
1984	Linda King	Track and Field
1984	Bruce Smith	Football
1985	Linda King	Track and Field
1985	Mark Stickley	Track and Field
1986	George Canale	Baseball
1986	Dell Curry	Basketball
1986	Chris Kinzer	Football
1987	Gary Cobb	Track and Field
1987	Margarita Lasaga	Track and Field
1987	Trey McCoy	Baseball
1987	Phil Saunders	Track and Field
1987	Steve Taylor	Track and Field
1987	Steve Taylor	Cross Country
1987	Tony Williams	Track and Field

1987	Tony Williams	Cross Country
1989	Brian Walter	Cross Country
1990	Bimbo Coles	Basketball
1991	Eugene Chung	Football
1992	Mike Sergent	Track and Field
1993	Dee Dalton	Baseball
1993	Jim Pyne	Football
1994	Josh Feldman	Wrestling
1995	Cornell Brown	Football
1995	J.C. Price	Football
1995	Jenny Root	Women's Basketball
1996	Kevin Barker	Baseball
1996	Cornell Brown	Football
1996	Billy Conaty	Football
1996	Charlie Gillian	Baseball
1996	Oliver Mayo	Men's Tennis
1997	Matt Griswold	Baseball
1997	Pierson Prioleau	Football
1998	Erick Kingston	Track and Field
1998	Corey Moore	Football
1998	Katie Ollendick	Track and Field
1998	Derek Smith	Football
1999	Larry Bowles	Baseball
1999	John Engelberger	Football
1999	Barry Gauch	Baseball
1999	Aaron Marchetti	Men's Tennis
1999	Anthony Midget	Football
1999	Corey Moore	Football
1999	Jamel Smith	Football
1999	Michael Vick	Football
1999	Tere Williams	Women's Basketball
1999	Lisa Witherspoon	Women's Basketball
2000	Andre Davis	Football
2000	Sean Gray	Wrestling
2000	Brian Hunter	Track and Field
2000	Erick Kingston	Track and Field
2000	Dawn Will	Lacrosse
2000	Matt Lehr	Football
2000	Chris Martin	Wrestling
2000	Lee Suggs	Football
2000	Ben Taylor	Football
2001	Sean Gray	Wrestling
2001	Kristin Price	Track and Field
2001	David Pugh	Football
2001	Ben Taylor	Football
2001	Ronyell Whitaker	Football
2002	Brendon de Jonge	Golf
2002	Dee O'Connell	Track and Field
2002	Johnson Wagner	Golf
2002	Jake Grove	Football
2002	Willie Pile	Football
2003	Brendon de Jonge	Golf

2003	Marc Tugwell	Baseball
2003	Matt Dalton	Baseball
2003	Spyridon Jullien	Track and Field
2003	Marlies Overbeeke	Cross Country
2003	Kevin Jones	Football
2003	Jake Grove	Football
2003	DeAngelo Hall	Football
2004	Spyridon Jullien	Track and Field
2004	Bryant Matthews	Basketball

ATHLETIC CONFERENCE AFFILIATIONS

Virginia Intercollegiate Athletic Association (1895–1921)
Southern Intercollegiate Conference (1921–1923)
Southern Conference (1923–1965)
Independent/No Affiliation (1965–1978)
Metro Collegiate Athletic Association (1978–1995)
Big East Football Conference (1991–2004)
Atlantic Ten Conference (1995–2000)
Atlantic Coast Conference (2004–present)

Bowl History

1947—Sun Bowl, El Paso, Texas
Cincinnati 18, Tech 6

1966—Liberty Bowl, Memphis, Tennessee
Miami 14, Tech 7

1968—Liberty Bowl, Memphis, Tennessee
Mississippi 34, Tech 17

1981—Peach Bowl, Atlanta, Georgia
Miami 20, Tech 10

1984—Independence Bowl, Shreveport, Louisiana
Air Force 23, Tech 7

1986—Peach Bowl, Atlanta, Georgia
Tech 25, North Carolina State 24

1993—Independence Bowl, Shreveport, Louisiana
Tech 45, Indiana 20

1994—Gator Bowl, Gainesville, Florida
Tennessee 45, Tech 23

1995—Sugar Bowl, New Orleans, Louisiana
Tech 28, Texas 10

1996—Orange Bowl, Miami, Florida
Nebraska 41, Tech 21

1998—Gator Bowl, Jacksonville, Florida
North Carolina 42, Tech 3

1998—Music City Bowl, Nashville, Tennessee
Tech 38, Alabama 7

2000—Sugar Bowl, New Orleans, Louisiana
Florida State 46, Tech 29

2001—Gator Bowl, Jacksonville, Florida
Tech 41, Clemson 20

2002—Gator Bowl, Jacksonville, Florida
Florida State 30, Tech 17

2002—San Francisco Bowl, California
Tech 20, Air Force 13

2003—Insight Bowl, Phoenix, Arizona
California 52, Tech 49

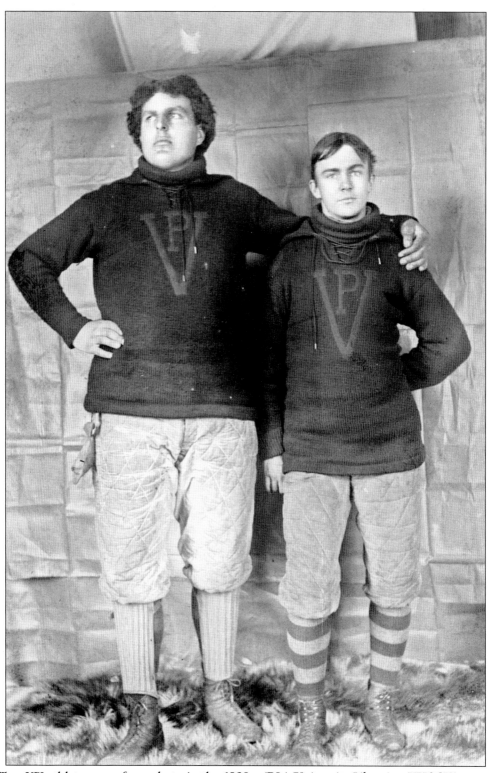

Two VPI athletes pose for a photo in the 1920s. (DLA/University Libraries, VPI&SU.)